# MAN RAY
## IN PARIS

# MAN RAY IN PARIS

## ERIN C. GARCIA

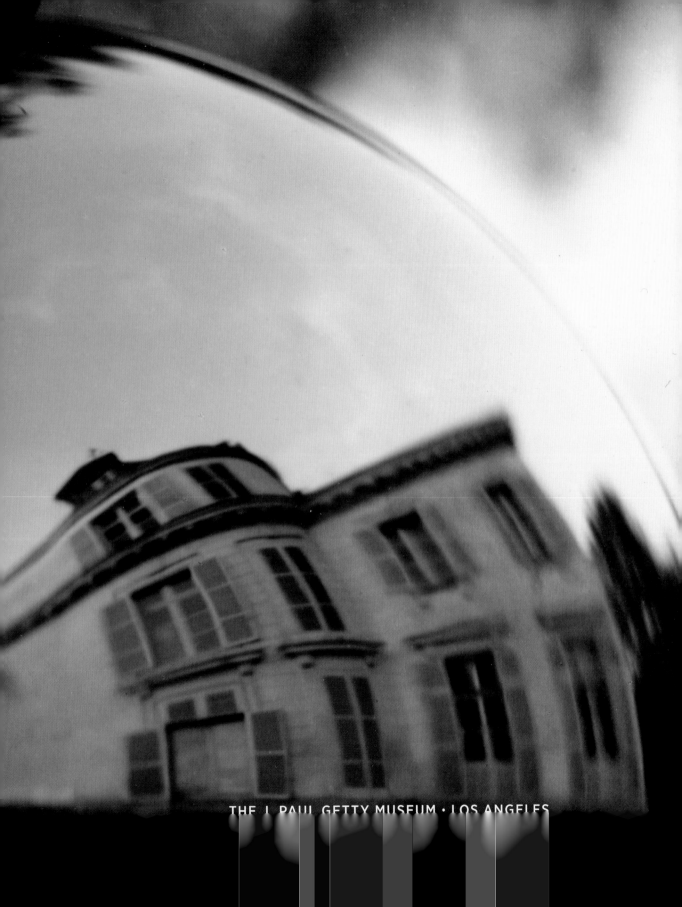

THE J. PAUL GETTY MUSEUM · LOS ANGELES

© 2011 J. Paul Getty Trust

**Published by the J. Paul Getty Museum, Los Angeles**

Getty Publications
1200 Getty Center Drive, Suite 500
Los Angeles, California  90049-1682
www.gettypublications.org

Gregory M. Britton, *Publisher*

Dinah Berland, *Editor*
Nomi Kleinmuntz, *Manuscript Editor*
Kurt Hauser, *Designer*
Stacy Miyagawa, *Production Coordinator*
Tricia Zigmund, *Photographer*
Gary Hughes, *Imaging Technician*

Color separations and press supervision by
Robert S. Hennessey and Sue Medlicott
Printed in China by Midas Printing International Limited

Library of Congress Cataloging-in-Publication Data

Garcia, Erin C.
  Man Ray in Paris / Erin C. Garcia.
     p. cm.
  Includes bibliographical references.
  ISBN 978-1-60606-060-5 (hardcover)
1.  Man Ray, 1890-1976—Criticism and interpretation.
2.  Photography, Artistic.  I. Man Ray, 1890-1976. II. Title.
  TR655.G369 2011
  779—dc22
                            2010037148

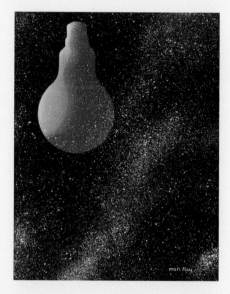

NOTE: All illustrations listed in the captions on this page
are by Man Ray (American, 1890–1976).

FRONT JACKET: Untitled (Eiffel Tower) (detail,
plate 3), 1922

BACK JACKET: *Noir et Blanche* (Black and White)
(detail, plate 42), 1926

FRONTISPIECE: Untitled (Distorted House) (detail,
fig. 10), 1928

THIS PAGE: *Électricité*, 1931. From the portfolio
*Électricité* (Electricity). Photogravure, 26 x 20.5 cm
(10 ¼ x 8 ⅟₁₆ in.). JPGM 84.XM.1000.97

PAGES 6–7: Untitled (Marcel Duchamp and Raoul de
Roussy Playing Chess) (detail, plate 7), 1925; PAGE 8:
*Noire et Blanche* (Black and White) (detail, plate 42),
1925; PAGE 29: *Rrose Sélavy* (Marcel Duchamp) (detail,
plate 4), 1923; PAGE 39: Untitled Rayograph (Gun with
Alphabet Stencils) (detail, plate 11), 1924; PAGE 51:
Untitled (The Marquise Casati) (detail, plate 20), 1922;
PAGE 65: Untitled Rayograph (detail, plate 34), 1922;
PAGE 73: *Le Violin d'Ingres* (Ingres' Violin) (detail,
plate 37), 1924; PAGE 89: *Le Monde* (The World) (detail,
plate 53), 1931; PAGE 97: *Calla Lilies* (detail, plate 56),
1930; PAGE 105: Untitled (Still Life for *Minotaur*) (detail,
plate 61), 1933; PAGE 111: *Duchamp—Porte bouteille*
(Duchamp—Bottle Dryer) (detail, plate 64), 1936

# Contents

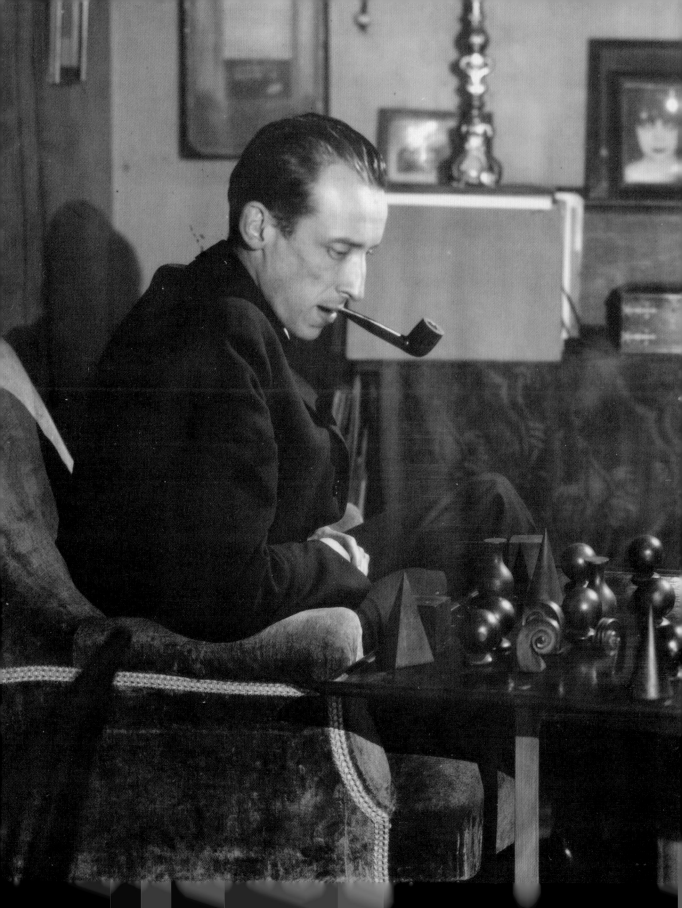

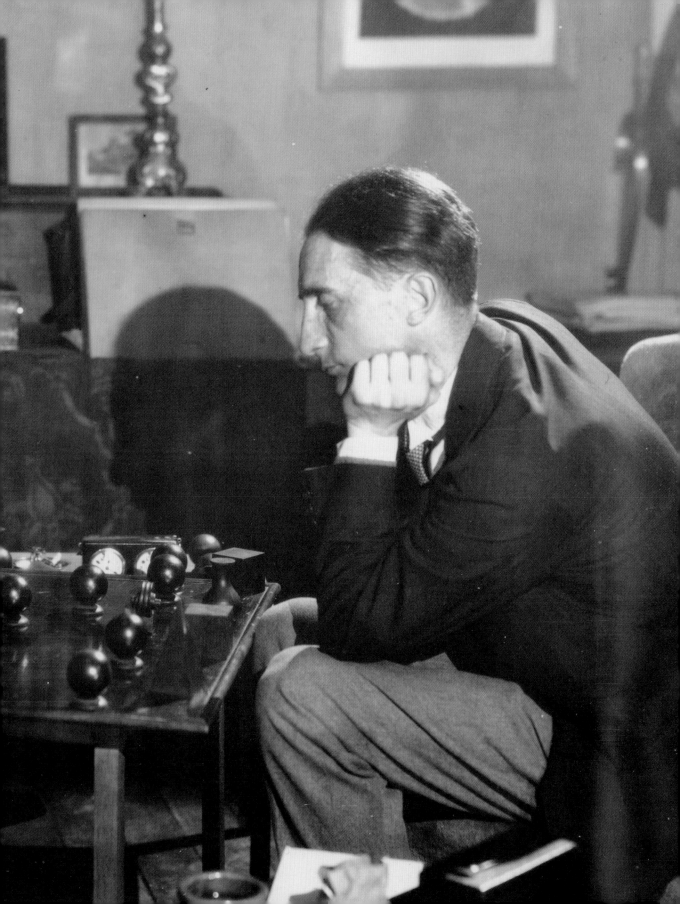

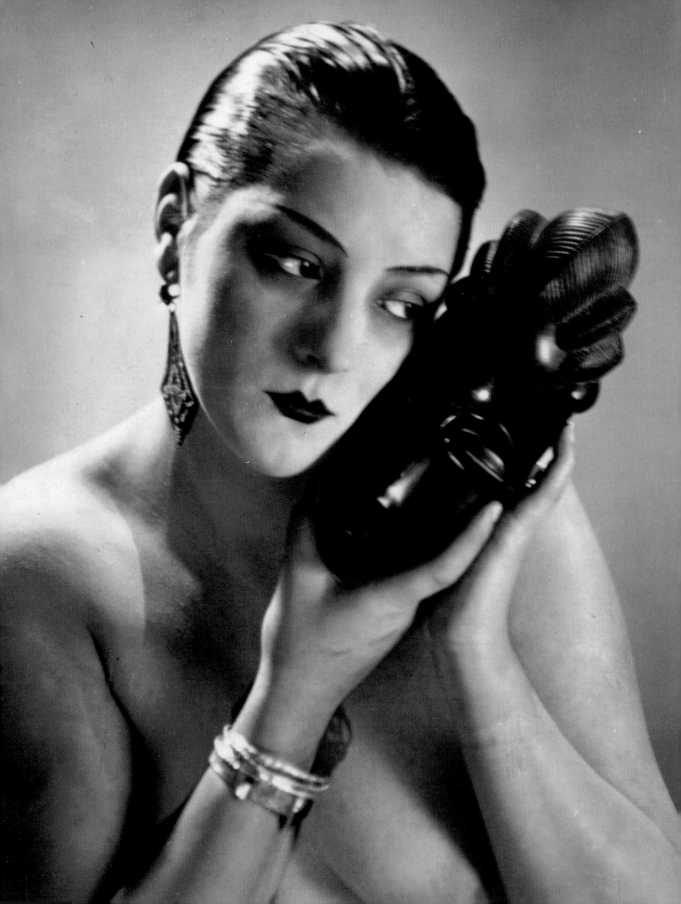

# MAN RAY
## IN PARIS

Paris in the 1920s was teeming with Americans. Bon vivants seeking escape from Prohibition mingled with artists and intellectuals, all pursuing their dreams in the City of Light. The art scene in Paris emerged from World War I newly invigorated and open to a wide range of creative expression.

Man Ray arrived from New York in 1921 at age thirty, entering the prime of his life at a seminal moment in history. Paris offered what New York could not—a receptive community of artists, dealers, and patrons who appreciated modern art and could support the radically inventive work he wanted to make. The two decades he spent in Paris, until 1940, were the most productive of his career.

Although he considered himself first and foremost a painter, Man Ray also made sculptures, films, and photographs. Magazine and portrait photography provided him an income and put him in contact with the rich, the famous, and the fashionable. At the same time, he made himself a fixture in the bohemian cafés of Montparnasse. Man Ray traveled among the expatriates, drank in the same bars they did, and took their pictures, yet he experienced Paris differently. He sought out the Parisian avant-garde and not only was admitted into its inner circle but eventually became a leading visual artist of the French Surrealist movement. From all sides, Man Ray maintained a great degree of autonomy.

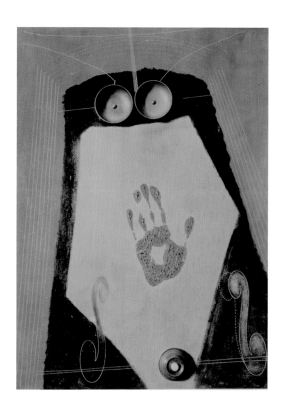

FIGURE 1. Man Ray (American, 1890–1976), *Self-Portrait*, 1916. Gelatin silver print, 9.5 x 7 cm (3¾ x 2¾ in.).
© Man Ray Trust ARS-ADAGP. Los Angeles, J. Paul Getty Museum, 86.XM.626.22

Born Emmanuel Radnitsky in 1890 in Philadelphia to immigrant, Russian-Jewish parents, Man Ray started his career as a draftsman and graphic designer in New York around 1911. With the landmark Armory Show in 1913 and the influx of European artists fleeing the battlegrounds of World War I, New York was learning about Modernism. Man Ray befriended European writers and artists (who later became his Parisian colleagues) and frequented Alfred Stieglitz's Gallery 291, where he discovered works by Paul Cézanne, Pablo Picasso, and Constantin Brancusi.[1] Man Ray was captivated by the inimitable Stieglitz, who spoke about a secessionist break with the past and photography's potential as a modern art form.[2]

Around 1915 Man Ray began experimenting with photography as a means of documenting his work in other media. In an early example he photographed *Self-Portrait* (1916)—an assemblage featuring doorbells, a push button, and a handprint on canvas—for his second solo exhibition at the Daniel Gallery in New York in 1916 (fig. 1).[3] Man Ray enjoyed the impenetrability of this self-portrait—a door that could not be opened with a bell that could not be rung. He was beginning to make art that focused on ideas. His delight in the irreverence of his self-portrait assemblage reflected his new friendship with the iconoclastic artist Marcel Duchamp, who was making "readymades": ordinary objects transformed into art by being placed in a gallery setting. The two collaborated on a series of photographs in which Man Ray would typically document Duchamp in an act of performance of some kind, as in Untitled (Duchamp with Glider) (fig. 2), in which Duchamp is wrestling with one of his glass paintings.

Through Duchamp, Man Ray aligned himself with European Dada, a cultural movement that responded to the brutality of World War I by rejecting reason and logic in favor of anarchy and the absurd. The two artists published the single-issue magazine *New York Dada* (April 1921) and helped patroness Katherine Dreier found a museum devoted to modern art called Société Anonyme (Anonymous Society).[4] Despite these fledgling attempts to bring Dada to New York, Man Ray ultimately concluded that the American public was not ready for it.[5] When Duchamp returned to Paris, Man Ray resolved to follow.

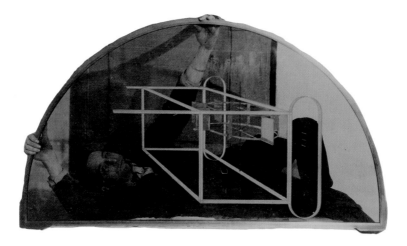

In July 1921, after a transatlantic journey aboard the SS *Savoie* and a train ride to Paris, Man Ray was immediately welcomed by Dada's exclusive members. Duchamp whisked him from the Saint-Lazare station to a residential hotel in the sixteenth arrondissement and then took him to meet his new colleagues at Café Certa. The secluded café, located in a shopping arcade far from the artists' quarters of Montparnasse and Montmartre, served as Dada's headquarters. There Man Ray met writers André Breton, Philippe Soupault, Louis Aragon, and others. The group had a tendency to be indifferent to newcomers, but Man Ray had already ingratiated himself to them with his efforts to promote Dada in New York. Man Ray was also slightly older than the others; this fact, and his status as an American, may have won him a measure of deference as well. From the café, the evening continued with dinner at an Indian restaurant, followed by a street fair. By the end of his very first day in Paris, Man Ray found himself surrounded by a coterie of friends and supporters.[6]

FIGURE 2. Man Ray, Untitled (Duchamp with Glider), 1917. Gelatin silver print, 8.6 x 15.4 cm (3 ⅜ x 6 ¹⁄₁₆ in.). © Man Ray Trust ARS-ADAGP. Los Angeles, J. Paul Getty Museum, 86.XM.626.4. Pictured is Marcel Duchamp (French, 1887–1968) with his glass painting *Glider Containing a Water Mill in Neighboring Metals*, 1913–15.

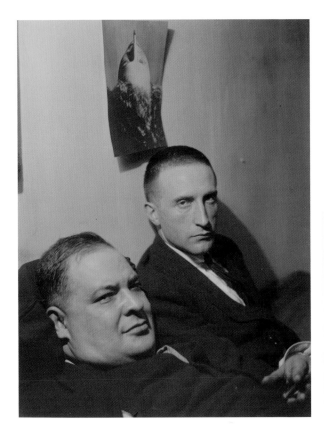

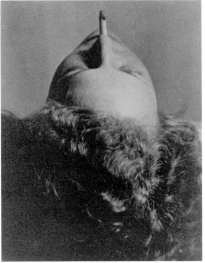

FIGURE 3. Man Ray, *Joseph Stella and Marcel Duchamp*, 1920. Gelatin silver print, 20.5 x 15.6 cm (8 ¹⁄₁₆ x 6 ⅛ in.). © Man Ray Trust ARS-ADAGP. Los Angeles, J. Paul Getty Museum, 84.XM.1000.152. Taken at the Société Anonyme, showing May Ray's *Woman Smoking a Cigarette* (see fig. 4) tacked to the wall.

FIGURE 4. Man Ray, *Woman Smoking a Cigarette*, 1920. Gelatin silver print, 8.6 x 6.8 cm (3 ⅜ x 2 ¹¹⁄₁₆ in.). © Man Ray Trust ARS-ADAGP. Los Angeles, J. Paul Getty Museum, 84.XM.1000.43

Four months later Man Ray had his first Paris exhibition at Librairie Six, the bookstore run by Soupault's wife, Mick. The Dadaists promoted the opening as their first event of the winter season. They festooned the space with balloons and then, in the mischievous spirit of Dada, set them off popping by lighting the strings with their cigarettes.[7] The exhibition featured Man Ray's aerographs, paintings he had made in New York using an innovative airbrush technique. Graphically stream-lined and lacking conventional brushwork, the paintings had a mechanized, futuristic sensibility and seemed to embody a certain American-ness that the Parisian avant-garde found highly desirable. Man Ray may not have identified himself as the personification of American industrialism, but the exhibition nonetheless confirmed his special status.[8]

FIGURE 5. Man Ray, *L'Inquiétude* (Anxiety), 1920. Gelatin silver print, 9.3 x 12 cm (3 ¹¹⁄₁₆ x 4 ¾ in.). © Man Ray Trust ARS-ADAGP. Los Angeles, J. Paul Getty Museum, 86.XM.626.7

Invigorated by his new environs, Man Ray brimmed with creative energy, finding inspiration everywhere around him. He spontaneously created *Cadeau* (Gift, 1921) during the opening party at Librairie Six, when he ducked out for a drink and returned with an iron, carpet tacks, and glue collected from a nearby hardware store (see fig. 6). The assemblage—which became a last-minute addition to the show—took Duchamp's idea of the readymade a step farther by juxtaposing seemingly incongruous elements.[9] Soon after, Man Ray brought the same spirit of serendipity to his Rayographs, abstract images he made by placing objects directly on photographic paper and exposing them to light.

It did not take long for Man Ray to acclimate to his new home. He learned French quickly and felt secure in the hospitality of his new friends. He wrote to his family in 1922 after a brief illness, "While I was laid up, I had a dozen friends working for me, bringing me things to eat, heating my studio, in fact, you know I've never been ill, and this was a real treat."[10] He moved to Montparnasse, on the Left Bank, with his new love interest, an artist's model known in the quarter as Kiki of Montparnasse (Alice Prin; see plates 12, 37, 39, 42, 45). He also rented a comfortable artist's studio in a desirable building at 31 bis rue Campagne Première, where he set up a small darkroom on the second floor. For the next decade, the address served as Man Ray's workplace, party space, and occasional residence.[11]

Montparnasse gave Man Ray a sense of community and a rich social life. On all sides he was surrounded by friends and artists. Duchamp moved to the hotel next door. The elderly photographer Eugène Atget, part of an earlier generation of artisans and tradespeople who inhabited the quarter, lived down the street. Together with Kiki, Man Ray became a familiar character in the social scene of Montparnasse. The couple was well known at Café du Dôme and La Coupole. These and other fashionable cafés served as meeting places by day and nightclubs after dark. American jazz musicians, female impersonators, and cabaret singers—including Kiki—provided entertainment.[12]

The denizens of Montparnasse also became Man Ray's clients. As an extension of his work documenting art, he established himself as a portrait photographer

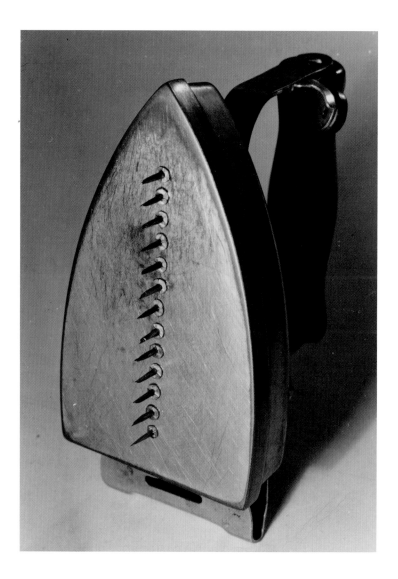

**FIGURE 6.** Man Ray, *Cadeau* (Gift), 1944. Gelatin silver print, 16.2 x 11.6 cm (6 ⅜ x 4 ⁹⁄₁₆ in.). © Man Ray Trust ARS-ADAGP. Los Angeles, J. Paul Getty Museum, 87.XM.57.3. Man Ray made the original assemblage, also titled *Cadeau*, during the opening of his exhibition at Librairie Six in 1921; the object was stolen that evening. He re-created it repeatedly throughout his career and in 1944 made this photograph of one of these versions.

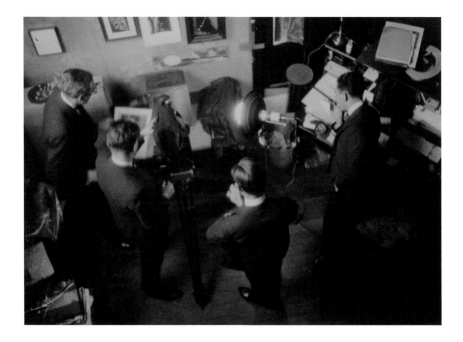

in the local artistic community. One of his first portraits was of Jean Cocteau framing his face with an empty picture molding (plate 23). Word-of-mouth connections brought sitters from the English-speaking expatriate community, such as legendary art collector and author Gertrude Stein (see plate 25) and writers in need of publicity photographs.[13] James Joyce came to him just before the release of his novel *Ulysses*, and Sinclair Lewis posed after a night at the cafés in front of a wooden wine press, a sculptural readymade that Brancusi reportedly found in an antique shop (see plates 24 and 22, respectively).[14]

Although Man Ray took little pleasure in his work as a portraitist, his celebrity portraits regularly appeared in *Vanity Fair*, and he began doing fashion work for *Vogue* and *Harper's Bazaar*.[15] The magazines provided a modest but steady stream

FIGURE 7. Etienne de Beaumont (French, 1883–1956), Untitled (Man Ray's Studio), 1920–29. Gelatin silver print, 15.4 x 21.3 cm (6 1/16 x 8 3/8 in.). [No known copyright claimant.] Los Angeles, J. Paul Getty Museum, 84.XM.1000.63

of income; financial windfalls came, quite unexpectedly, from other sources. Arthur Wheeler, a retired broker and patron of the arts, offered to fund Man Ray's second experimental film, *Emak Bakia* (Leave Me Alone, 1926). Man Ray used only half of the $10,000 sum to make the movie; the rest he sent to his sister in $1,000 and $2,000 checks for deposit in his New York bank account as an emergency fund. For the time being, he was living comfortably enough and even owned a car.[16]

Over the course of the 1920s, the Dada group that had so warmly welcomed Man Ray disintegrated. Its proponents were bitterly divided over Dada's aims; one of the leading figures, Tristan Tzara, emphasized spontaneous public demonstrations, but Breton advocated a more rigorous investigation of the subconscious. Out of the warring factions, the Surrealist movement emerged. While its initial intent was literary, Surrealism eventually took on increasingly visual dimensions.[17] The Surrealists' taste in art was eclectic. Their official journal, *La Révolution surréaliste* (The Surrealist Revolution), reproduced paintings and photographs, and Man Ray was listed as the official photographer. The journal sometimes featured images, produced by anonymous makers or other photographers, that the group found to be inherently Surrealist; removed from their original contexts and given different titles, these pictures assumed strange new meanings. The journal's June 1926 cover, for example, shows Atget's 1912 photograph of a crowd staring at an eclipse through special viewing devices, with the enigmatic caption *Les Dernières conversions* (The Last Conversions) (fig. 8).

As Surrealism gathered momentum, Man Ray's work evolved, becoming increasingly provocative and disturbing over the years. The lighthearted quality of his early assemblages and aerographs gave way to more sinister imagery, such as his 1930 *La Prière* (The Prayer; plate 48). The disorienting picture shows a woman's feet, hands, and buttocks emerging from darkness. Although Man Ray photographed nudes throughout his career, here the uncomfortable pose, the protective placement of the woman's hands, and the title all suggest subjugation. The theme of sadism is even more apparent in his 1936 *Vénus restaurée* (Restored Venus), a shadowy image of a plaster cast of a fragmented female torso bound with rope (plate 49).[18]

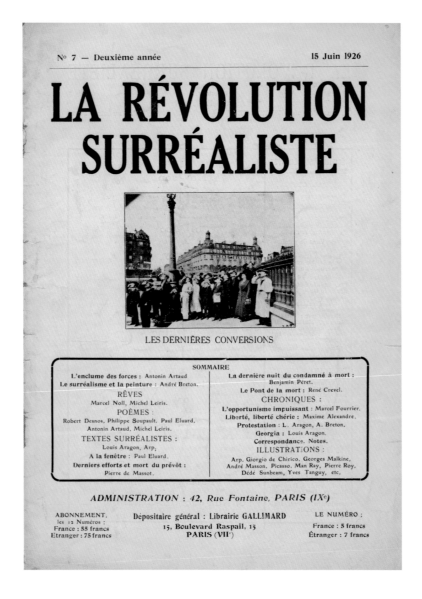

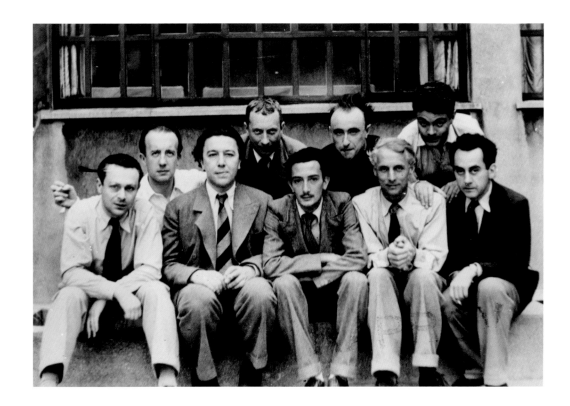

FIGURE 9. Man Ray, Untitled (The Surrealists), negative, 1930; print, n.d. Gelatin silver print, 12.5 x 18.3 cm (4 15/16 x 7 3/16 in.). © Man Ray Trust ARS-ADAGP. Los Angeles, J. Paul Getty Museum, 84.XM.1000.143. Sitters are, from left to right (back row), Paul Eluard, Hans Arp, Yves Tanguy, René Crevel; (front row) Tristan Tzara, André Breton, Salvador Dalí, Max Ernst, and Man Ray.

Man Ray's personal life in the 1930s was undergoing changes as well. His relationship with Kiki ended in 1929. The American Lee Miller became Man Ray's assistant and lover, but she never pledged loyalty and ultimately moved on. By the end of the 1930s Man Ray was living with Adrienne Fidelin, a dancer he met on the beach in Antibes. As artists and writers moved out of Montparnasse and tourists flooded in, Man Ray gave up his studio on Campagne Première for one with an apartment several blocks away. He also had homes outside the city where he could retreat and paint—first in Antibes and later in Saint-Germain-en-Laye, just west of Paris. Work and money were increasingly hard to come by. Not long after the 1929 stock market crash in the United States the repercussions could be felt in France. Man Ray sent money to his family as long as he could, but he eventually found himself concerned with meeting his own expenses.[19]

With his portrait clientele dwindling in the mid-1930s, he bolstered his business by exhibiting his Rayographs to reassert himself as an avant-garde photographer.[20] His contempt for portraiture still unabated, he expressed his frustration in a letter as follows:

> I keep turning out flocks of photographs, if not for the instruction, at least for the entertainment of the human race. And I get no pay for it except this feeling of how useful I am to this race. They come with enthusiastic expression on their face: "Will you do a picture of me for this or that event, you are the only one who can do something with my face," and think I am pleased and flattered.[21]

He depended on his reputation as a photographer, but his portraiture eclipsed the work for which he wanted to be known. American arbiters gave proof to his anxieties, as he explained:

> I have painted all these years and if I brought over my things to New York I could fill a respectable gallery, but these one-track minded Americans have now put me down as a photographer—the Modern Museum, and others, even after having visited my place and seen my work. Do you wonder that I stay in Europe? I have here enough friends who support my work and exhibit it, and the fact that I do photography for a living instead of trying to sell paintings does not lower their estimation of my output.[22]

Just as he had hoped two decades earlier when he left New York, Man Ray felt best understood in Paris. Even under the worst conditions, he would be reluctant to leave.

Dire circumstances came soon enough. By the end of the decade, the onset of World War II had begun to weigh on him. He initially thought he could wait out the war and, despite increasingly frequent bombings, he covered the Paris fashion shows in the spring of 1940. Shortly after that, civilians were ordered out of Paris, and he fled to the south but was forced back during a cease-fire. Upon returning to a German-occupied Paris, Man Ray resolved to leave Europe and began getting his affairs in order. He put Adrienne and his Paris dealer in charge of his larger canvases, bank account, and house in Saint-Germain-en-Laye and then boarded a train with just a few pieces of hand luggage. He arrived in New York to find many of his Parisian friends exiled there, but the prospect of forging a new life in the city he'd left as a young man depressed him. Instead, Man Ray spent the war years in Hollywood with the woman who would become his wife, Juliet.[23]

Man Ray did not return to Paris until well after the war. He visited in 1947 and then moved back permanently in 1951 with Juliet. Thirty years after he had first arrived in Paris, Man Ray was a different man. Older and more experienced, he had a legendary career that made him a celebrity. Still, his desire to be in Paris was much the same. To American critics his success in fashion and portrait photography overshadowed his work in other media. His place in the art world was further complicated by his being an American in close association with French Surrealism. Paris once again promised to be more accepting. Indeed, in the twenty-five years before he died in 1976, he continued to work from his studio on rue Férou, across the Luxembourg Gardens from Montparnasse, in the newly christened artists' quarter of Saint-Germain-des-Prés. He painted, experimented with photography, assembled objects, prepared exhibitions, and wrote his autobiography. He socialized with old friends, received visitors interested in his life and work, and, at last, began to be recognized for his considerable contributions to Modernism.

## Notes

1 Francis Naumann, "Man Ray, 1908–1921: From an Art in Two Dimensions to the Higher Dimension of Ideas," in *Perpetual Motif: The Art of Man Ray*, ed. Merry A. Foresta (New York, 1988), p. 55.

2 Merry A. Foresta, "Perpetual Motif: The Art of Man Ray," in *Perpetual Motif* (note 1), p. 15.

3 Katherine Ware, *In Focus: Man Ray* (Los Angeles, 1998), p. 10.

4 Naumann, "Man Ray, 1908–1921" (note 1), p. 81.

5 Elizabeth Hutton Turner, "Transatlantic," in *Perpetual Motif* (note 1), p. 150. Turner reproduces a 1921 letter from Man Ray to Tristan Tzara complaining that "dada cannot live in New York." From the Bibliothèque Littéraire Jacques Doucet, in the Bibliothèque Sainte-Geneviève, Paris.

6 Billy Klüver and Julie Martin, "Man Ray, Paris," in *Perpetual Motif* (note 1), pp. 89–90; Roger Shattuck, "Candor and Perversion in No-Man's Land," in *Perpetual Motif* (note 1), p. 311; Herbert R. Lottman, *Man Ray's Montparnasse* (New York, 2001), pp. 10–15.

7 Klüver and Martin, "Man Ray, Paris" (note 6), p. 103.

8 Turner, "Transatlantic" (note 5), pp. 140–42.

9 Turner, "Transatlantic" (note 5), pp. 140–42.

10 In letters dated September 18 and October 25, 1922, Special Collections, Getty Research Institute, Los Angeles, Man Ray letters, 1922–1976 (hereafter "GRI, Man Ray letters").

11 Klüver and Martin, "Man Ray, Paris" (note 6), p. 123.

12 Lottman, *Man Ray's Montparnasse* (note 6), pp. 101–2, 119–28, 138–39, 157; Man Ray, *Self-Portrait* (Boston and New York, 1998), p. 123.

13 Sandra S. Phillips, "Themes and Variations: Man Ray's Photography in the Twenties and Thirties," in *Perpetual Motif* (note 1), p. 187; Ware, *In Focus: Man Ray* (note 3), p. 22.

14 Klüver and Martin, "Man Ray, Paris" (note 6), pp. 108–12; Turner, "Transatlantic" (note 5), pp. 153–58.

15 Phillips, "Themes and Variations" (note 13), p. 187.

16 In letters addressed to his sister, December 13, 1925, and January 11, January 29, March 18, and April 19, 1926, GRI, Man Ray letters; Lottman, *Man Ray's Montparnasse* (note 6), pp. 136–37; Turner, "Transatlantic" (note 5), p. 159.

17 Klüver and Martin, "Man Ray, Paris" (note 6), p. 91; Lottman, *Man Ray's Montparnasse* (note 6), pp. 113–18.

18 Lottman, *Man Ray's Montparnasse* (note 6), pp. 151–53.

19 Lottman, *Man Ray's Montparnasse* (note 6), pp. 171, 217; Man Ray, *Self-Portrait* (note 12), pp. 236–40. See letters dated December 16, 1930; [no month] 1931; February 16, 1932, GRI, Man Ray letters.

20 Man Ray, *Self-Portrait* (note 12), p. 235.

21 Man Ray, April 15, 1936, GRI, Man Ray letters.

22 Man Ray, April 15, 1936, GRI, Man Ray letters.

23 See his letter to his sister, April 6, 1938, GRI, Man Ray letters; Man Ray, *Self-Portrait* (note 12), pp. 235–41, 255, 259.

PLATES

PHOTOGRAPHS, 1920–1939

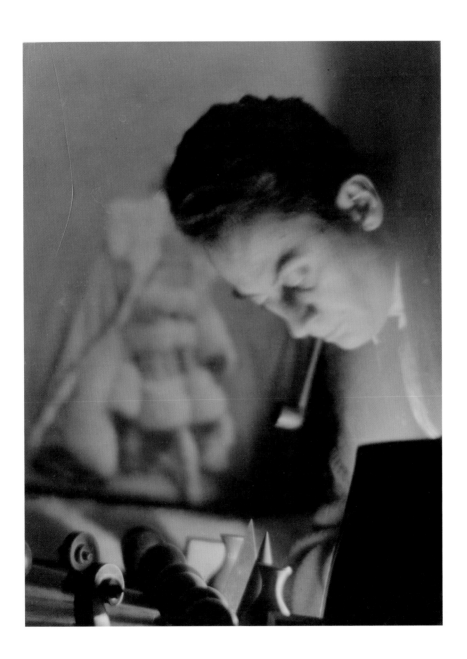

**PLATE 1** *"Selbstbildnis" avec les échecs* (Self-Portrait with Chess Set), 1921

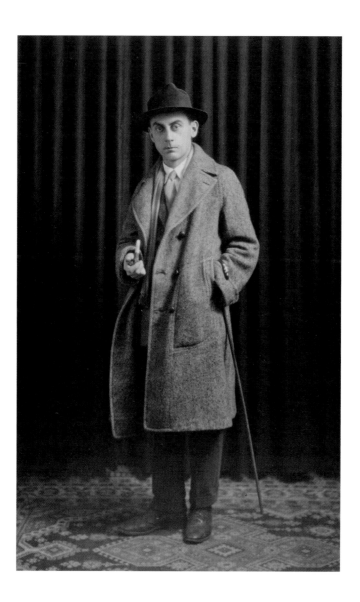

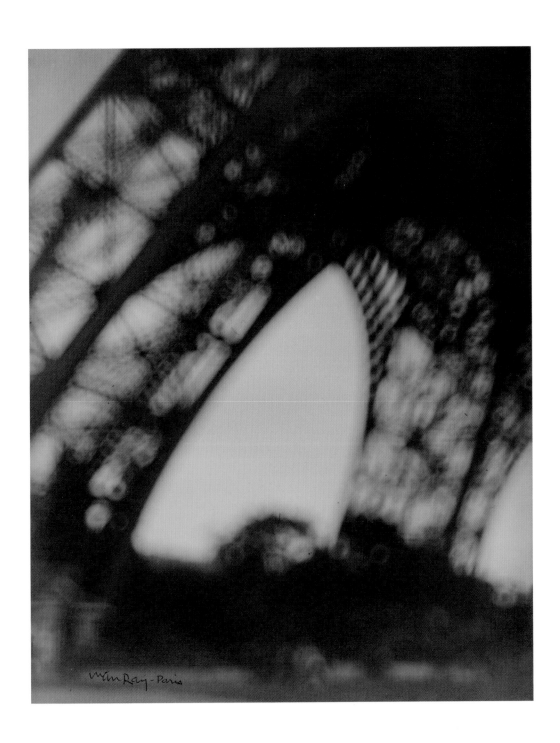

Before moving to Paris, Man Ray met Marcel Duchamp and the two became friends and collaborators. At first they did not speak the same language but communicated through games such as tennis and chess. They also made a series of photographs together in which Duchamp posed in drag as his breezy female alter ego, Rrose Sélavy, pronounced in French as *Eros, c'est la vie* (Eros, that's life; see plate 4).

# PLAYING GAMES

Influenced by Dada, Man Ray's early work embraced games of chance, performance, and word play. He returned to many of these themes throughout his career and repeatedly used imagery such as the chessboard and dice— as well as his own photographs— in subsequent works.

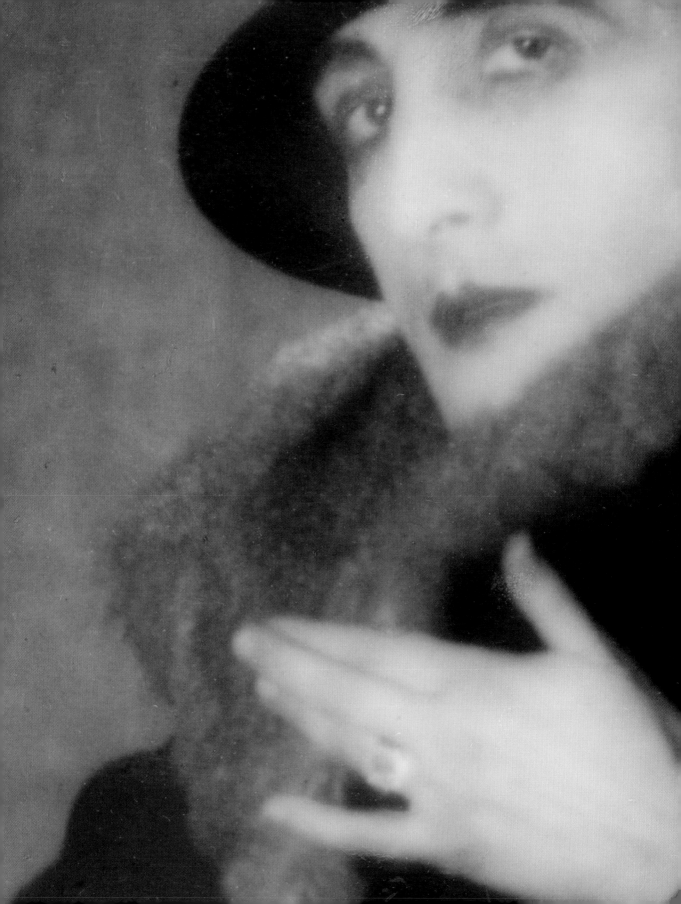

**PLATE 4**  *Rrose Sélavy* (Marcel Duchamp), 1923

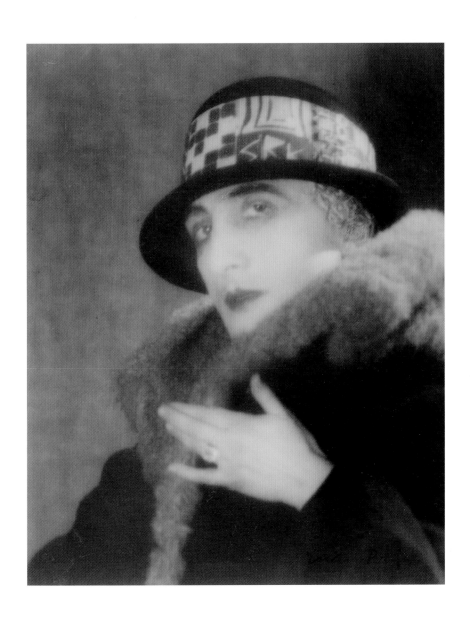

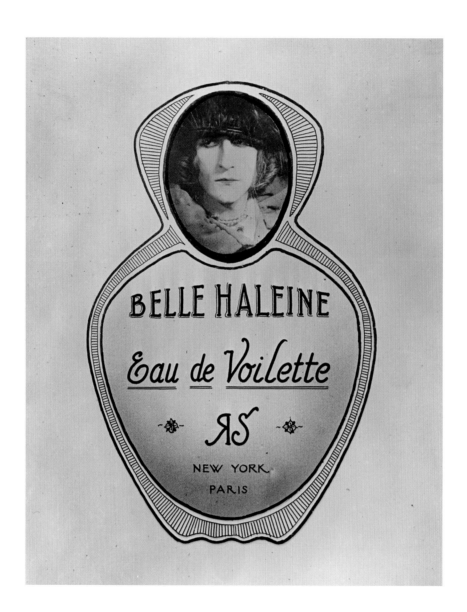

**PLATE 5** *Belle Haleine* (Beautiful Breath), 1921

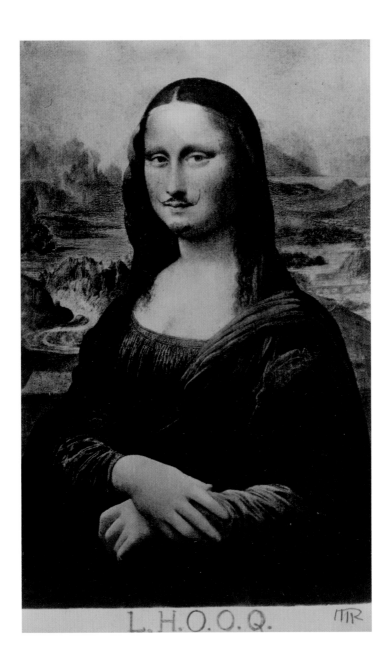

**PLATE 6** La Joconde *vue par Duchamp* (The *Mona Lisa* as Seen by Duchamp), 1921–22

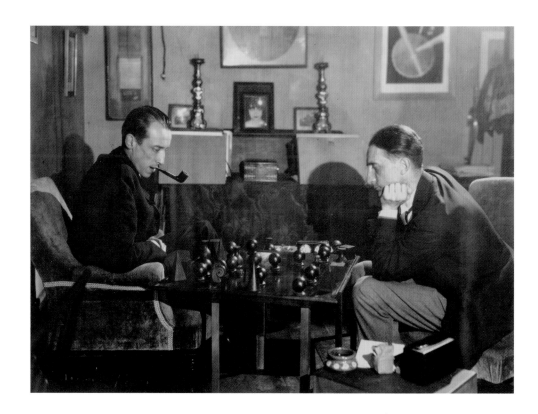

**PLATE 7** Untitled (Marcel Duchamp and Raoul de Roussy Playing Chess), 1925    **PLATE 8** Untitled (Pipe), 1933

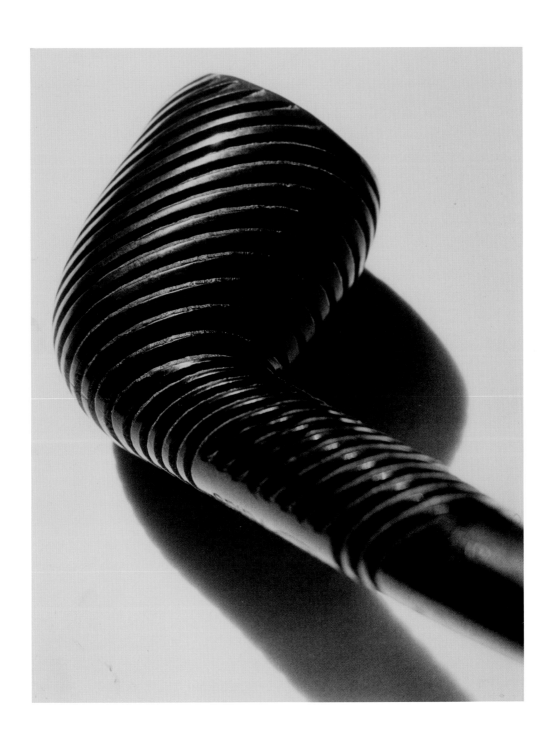

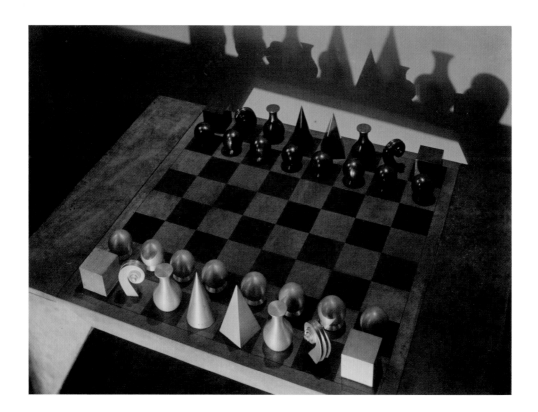

**PLATE 9** Untitled (Chess Set), 1926

**PLATE 10**  Untitled (Still Life for Nusch Eluard), 1925–30

Sometime in late 1921 or early 1922 Man Ray devised a way to make photographs without a camera. He placed various objects on a sheet of photographic paper and exposed the paper to light. In the tradition of inventors he named these abstract compositions Rayographs, after himself. Other Modernists were also making photograms, a rudimentary method of photography that dates back to the medium's inception. Man Ray's Rayographs were nonetheless ingenious. Like Duchamp's readymades, Rayographs transformed the odds and ends of everyday life into art.

# RAYOGRAPHS

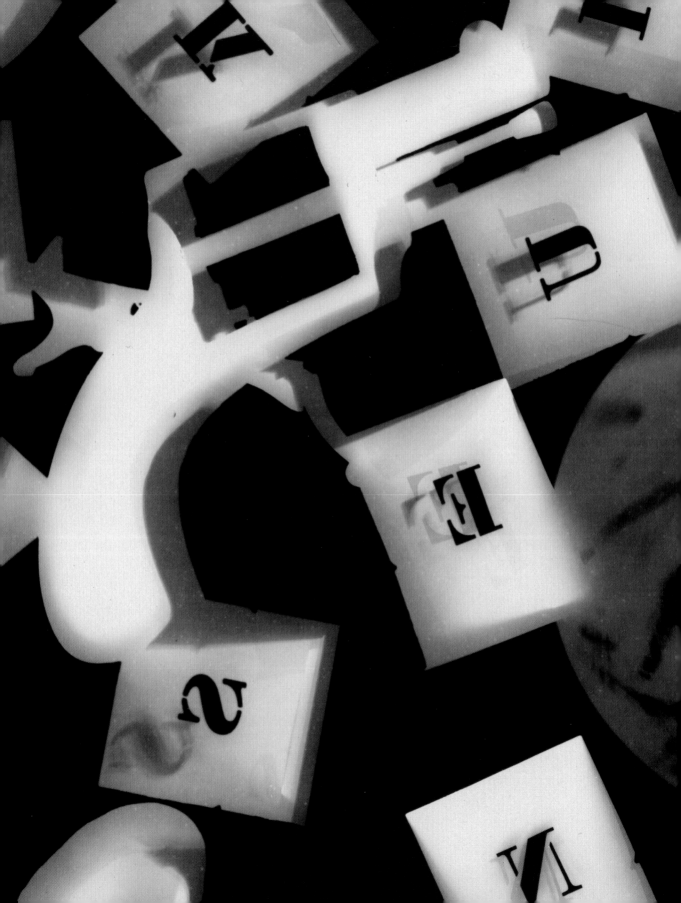

**PLATE 11** Untitled Rayograph (Gun with Alphabet Stencils), 1924

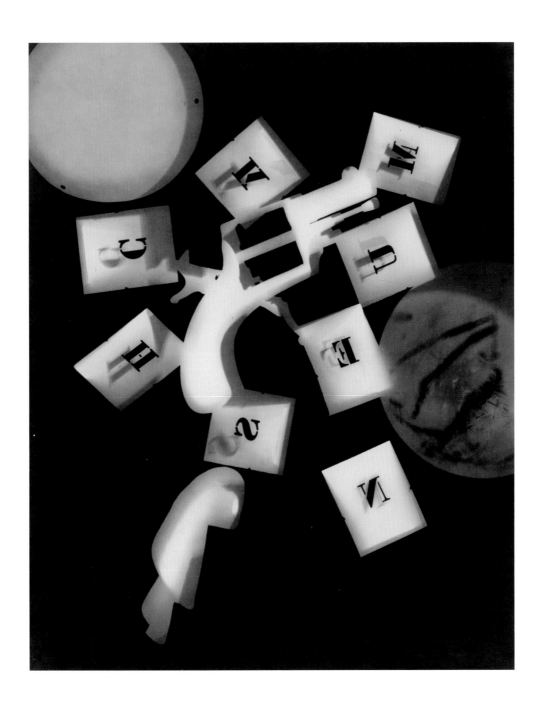

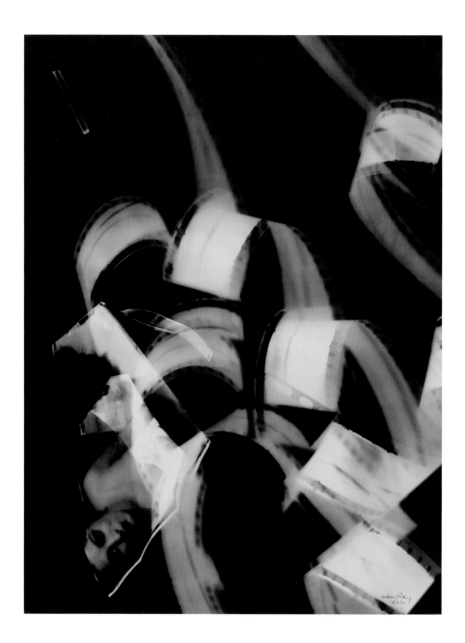

PLATE 12  Untitled Rayograph (Kiki and Filmstrips), 1922          PLATE 13  Untitled Rayograph, 1923

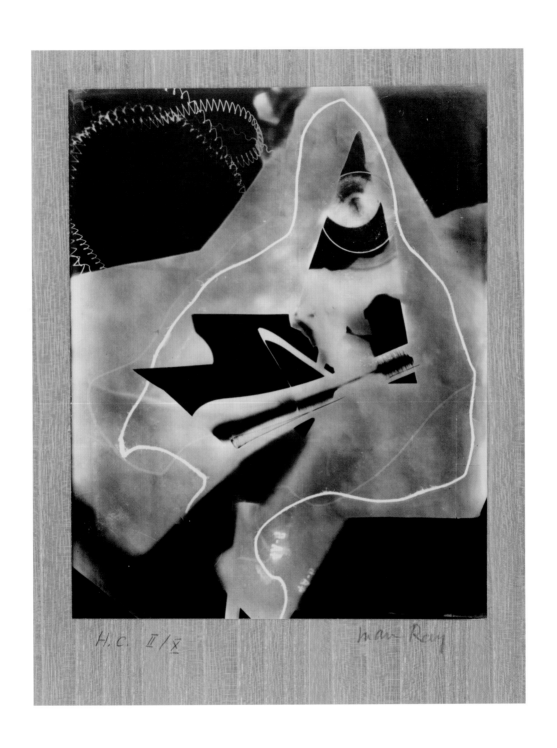

H.C. II/X                              man Ray

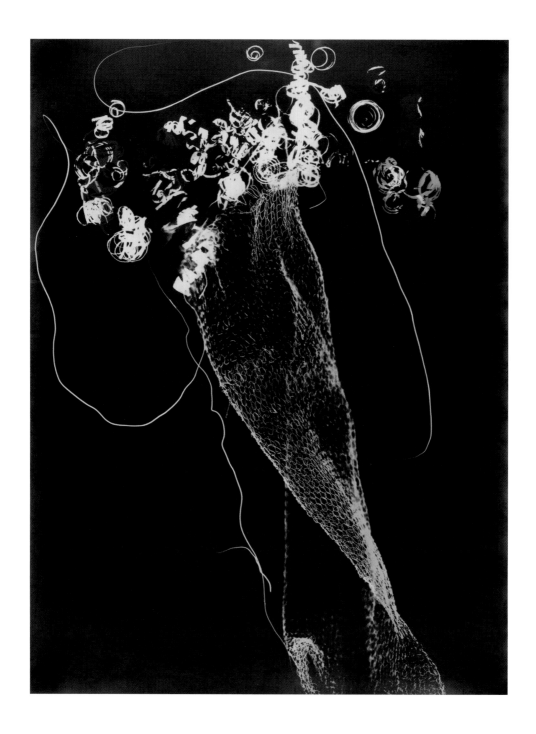

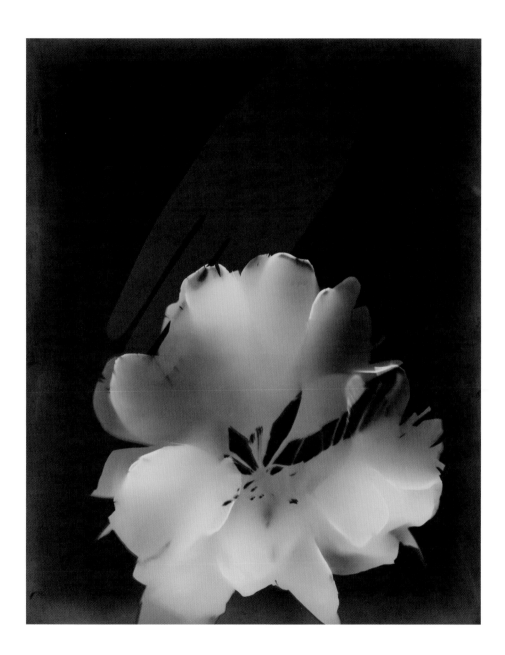

**PLATE 14**  Untitled Rayograph (Net and Shavings), 1924    **PLATE 15**  Untitled Rayograph (Hand and Flower), 1925

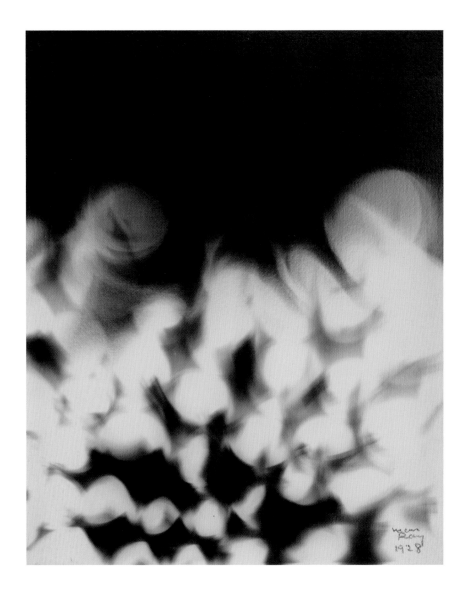

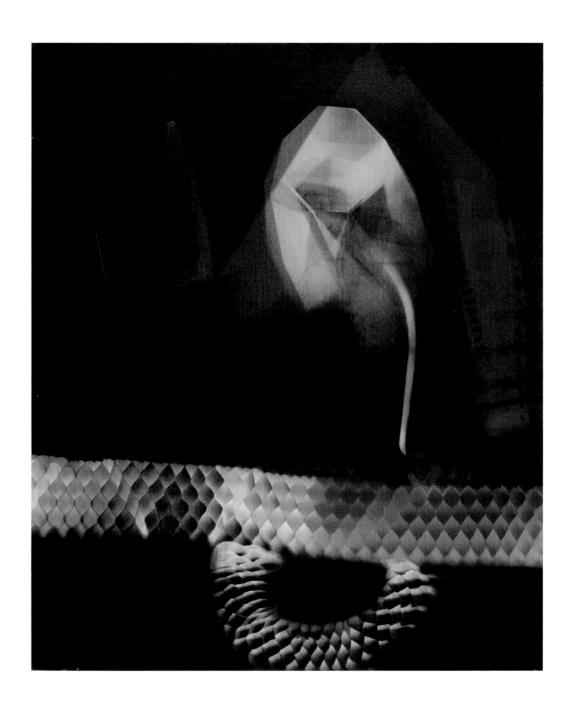

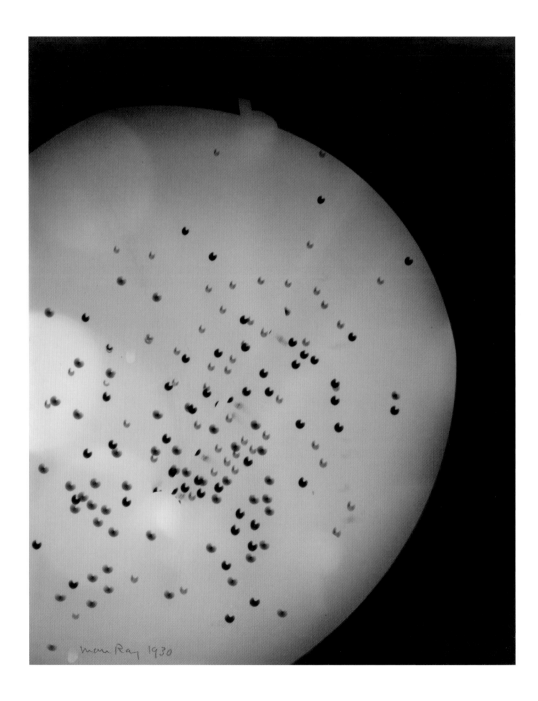

**PLATE 18** Untitled Rayograph (Sequins), 1930          **PLATE 19** *Necklace and Bracelet*, 1927

Man Ray's reputation as a portrait photographer brought him clients from the literary circles of Montparnasse. Socialites and celebrities also sought him out. A favorite sitter was the Marquise Luisa Casati, an aristocrat known for her eccentric appearance. Man Ray photographed her in 1922 surrounded by her favorite knickknacks. He later included a portrait from this sitting in a *cliché verre* (glass negative) composition titled *Nature Morte* (Still Life), 1924 (plate 29).

# PORTRAITURE

Man Ray photographed Casati years later, posing in front of two wooden horses at a masquerade ball in the persona of her idol, Empress Elisabeth of Austria, a free-spirited royal famous for her equestrian abilities (see plate 30).[1]

Note

1   Scot D. Ryersson and Michael Orlando Yaccarino, *The Life and Legend of the Marchesa Casati* (New York, 1999), pp. 141–42, 180–81.

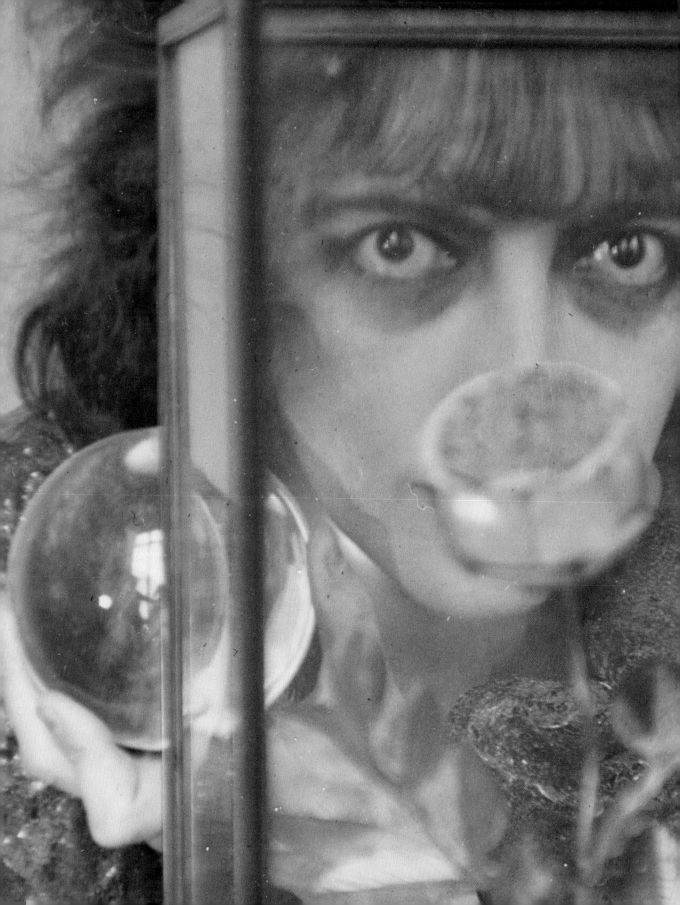

**PLATE 20**  Untitled (The Marquise Casati), 1922

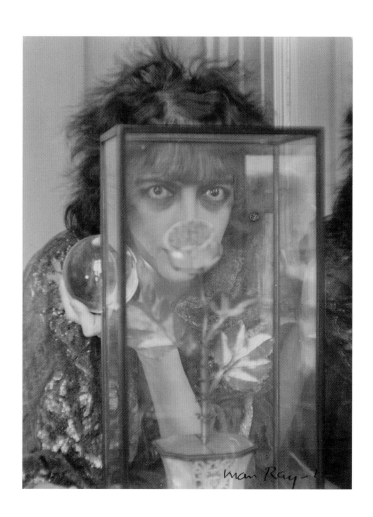

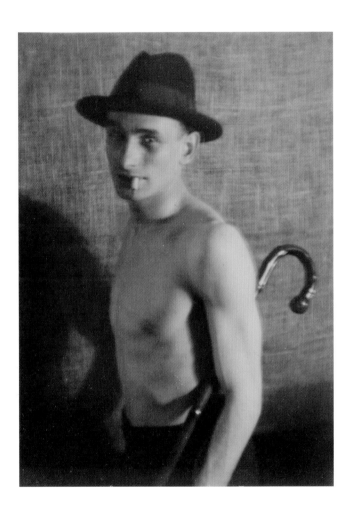

**PLATE 21** *Philippe Soupault,* 1922          **PLATE 22** *Sinclair Lewis,* 1922

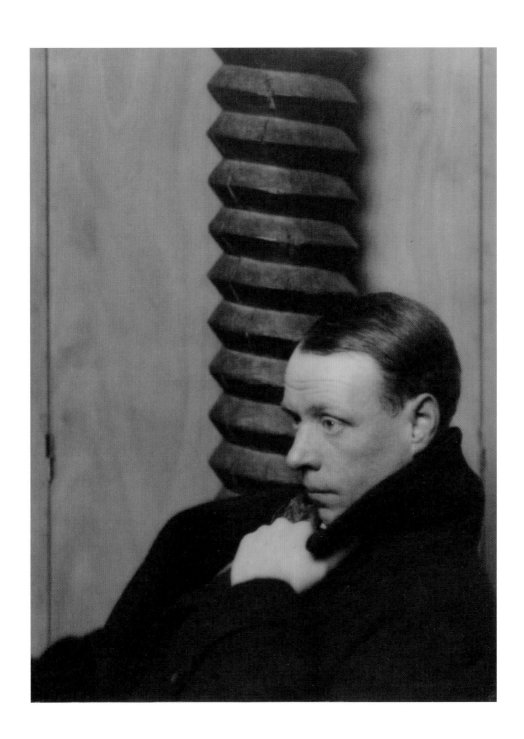

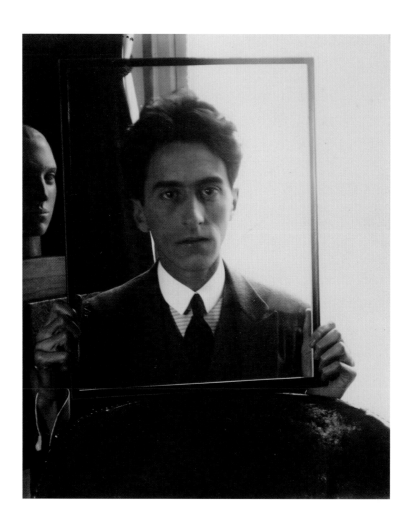

PLATE 23 *Jean Cocteau,* 1922          PLATE 24 *James Joyce,* 1922

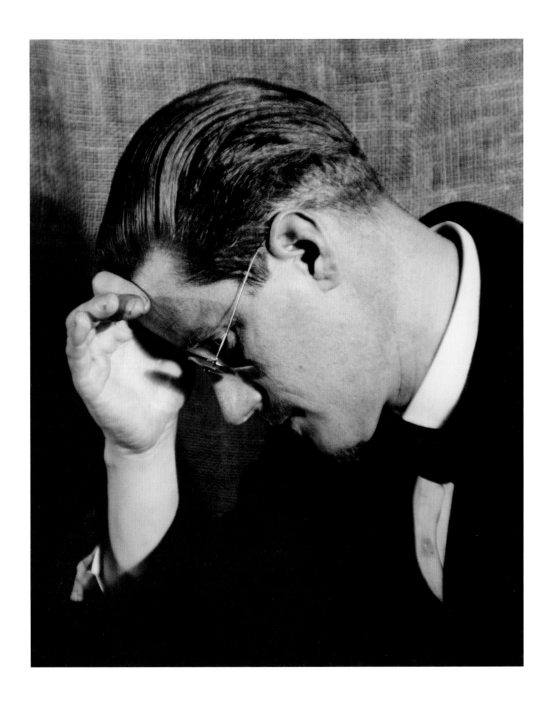

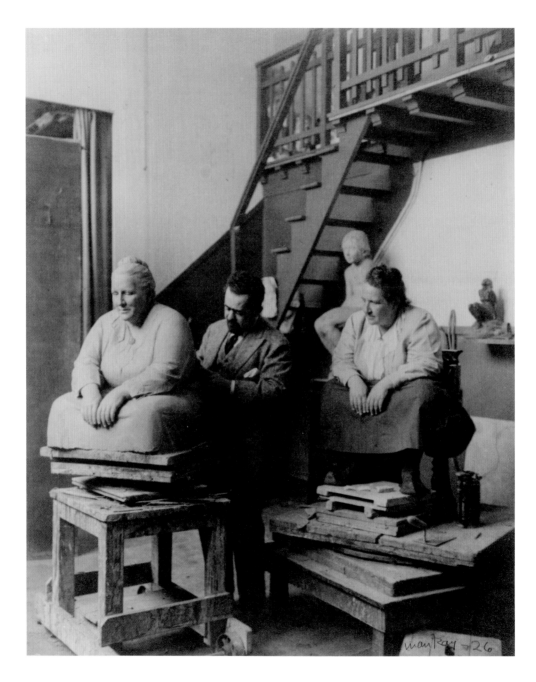

**PLATE 25** Untitled (Gertrude Stein Posing for Sculptor Jo Davidson), 1926

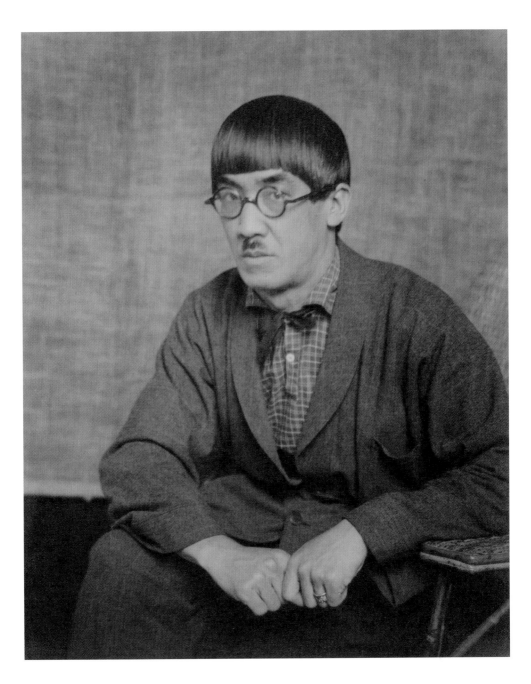

**PLATE 26** *Tsuguharu Fujita,* 1922

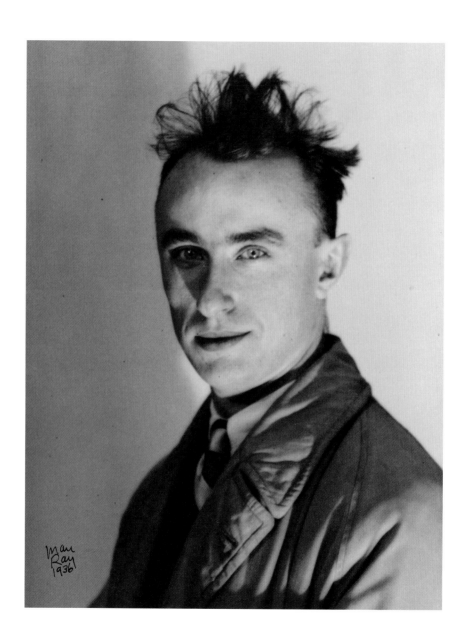

**PLATE 27** Untitled (Yves Tanguy), 1936

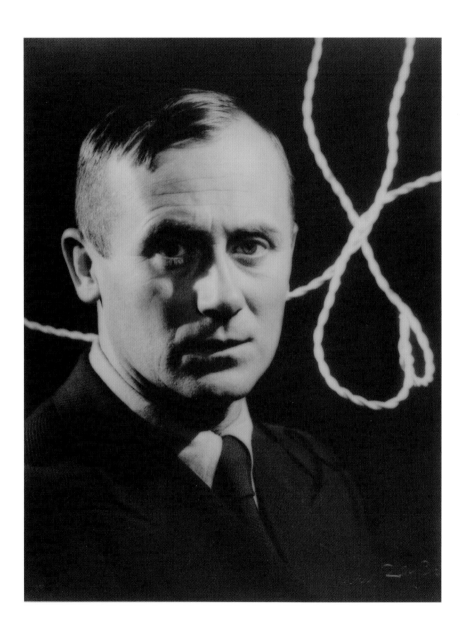

**PLATE 28** Untitled (Joan Miró), 1936

4-5

**PLATE 29** *Nature Morte* (Still Life), 1924

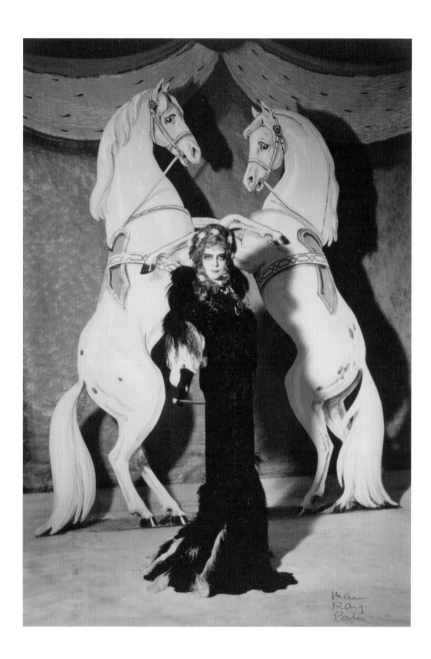

**PLATE 30** Untitled (The Marquise Casati with Horses), 1935

Tristan Tzara was so taken by Man Ray's Rayographs that he published twelve of them in 1922 in a portfolio titled *Les Champs délicieux* (The Delicious Fields). The title of the portfolio was derived from André Breton and Philippe Soupault's *Les Champs magnétiques* (The Magnetic Fields), a 1920 collection of automatic writings. Since each Rayograph was a one-of-a-kind print, with no reproducible negative, Man Ray photographed the Rayographs in order to make multiple copies.

# LES CHAMPS DÉLICIEUX
# THE DELICIOUS FIELDS

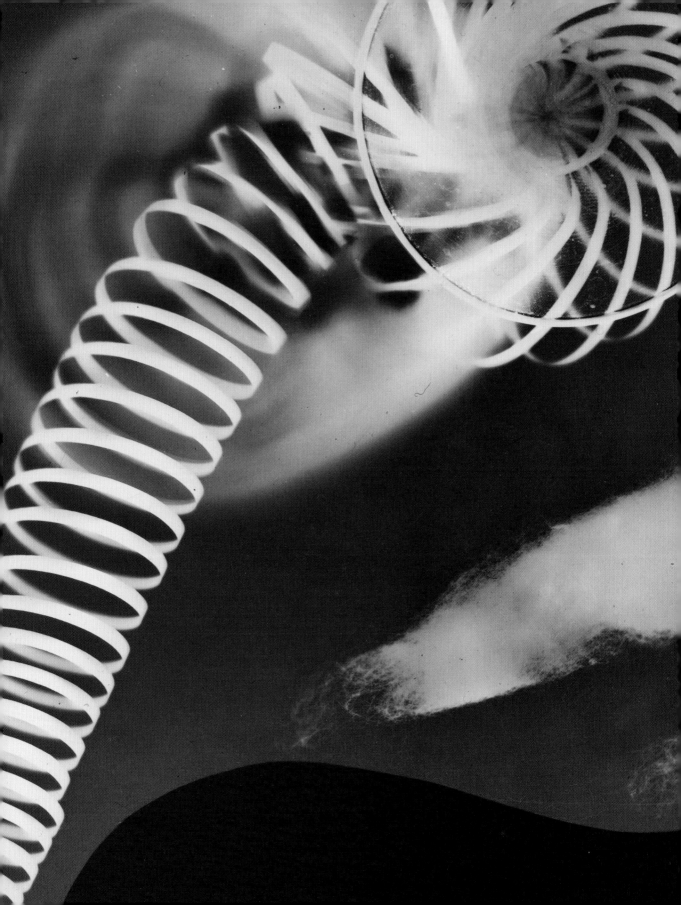

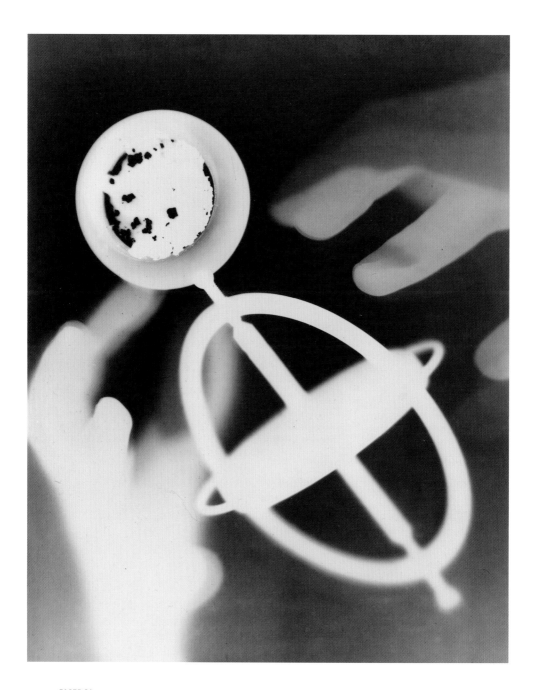

**PLATE 31** Untitled Rayograph, 1922

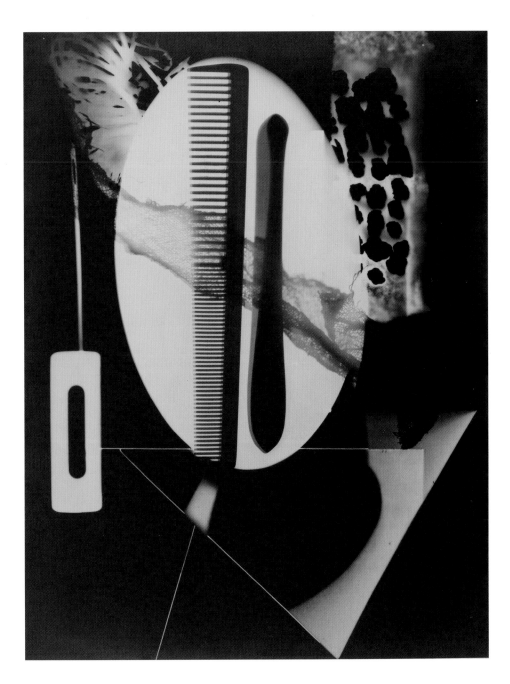

**PLATE 32**  Untitled Rayograph, 1922

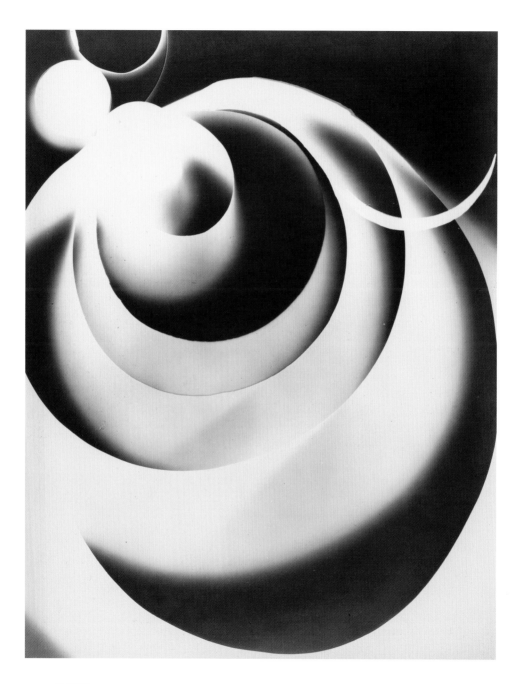

**PLATE 33** Untitled Rayograph, 1922

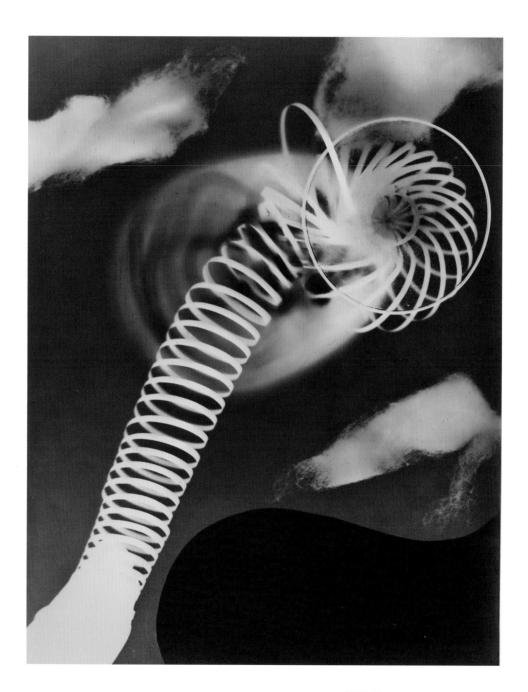

**PLATE 34** Untitled Rayograph, 1922

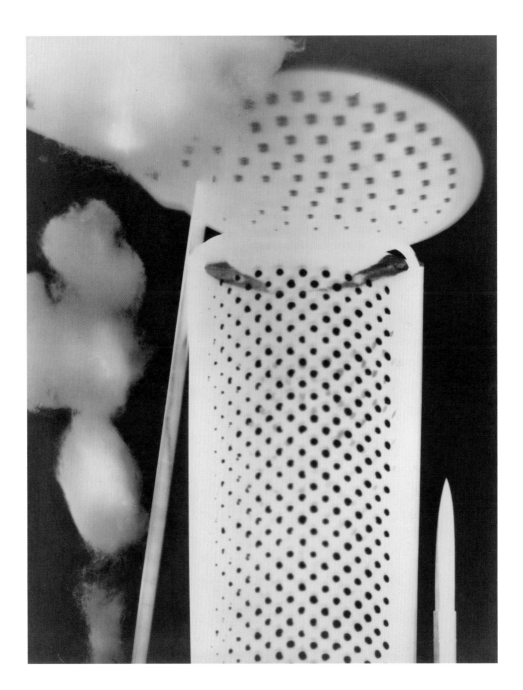

**PLATE 35**  Untitled Rayograph, 1922

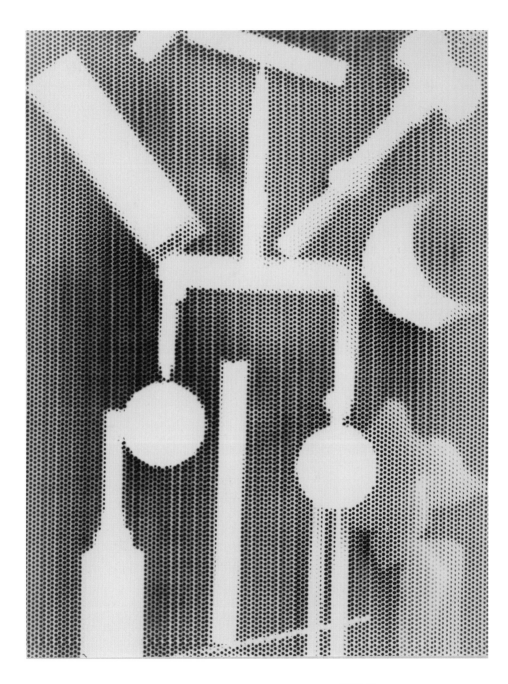

**PLATE 36** Untitled Rayograph, 1922

# WOMEN

Man Ray painted and photographed women throughout his career. Kiki of Montparnasse frequently served as his muse and model, appearing in his iconic photographs *Le Violon d'Ingres* (Ingres' Violin) (plate 37) and *Noire et Blanche* (Black and White) (plate 42). In Man Ray's pictures, women often became something other than themselves. He used unexpected camera angles, collage, or the introduction of props—such as African masks—to create oneiric images of his models. In *Larmes* (Tears) (plate 43), a woman's mascara-encrusted eyes morph into twin insects in an extreme close-up. He also photographed the female impersonator Barbette transforming himself into a woman with makeup (see plate 40).

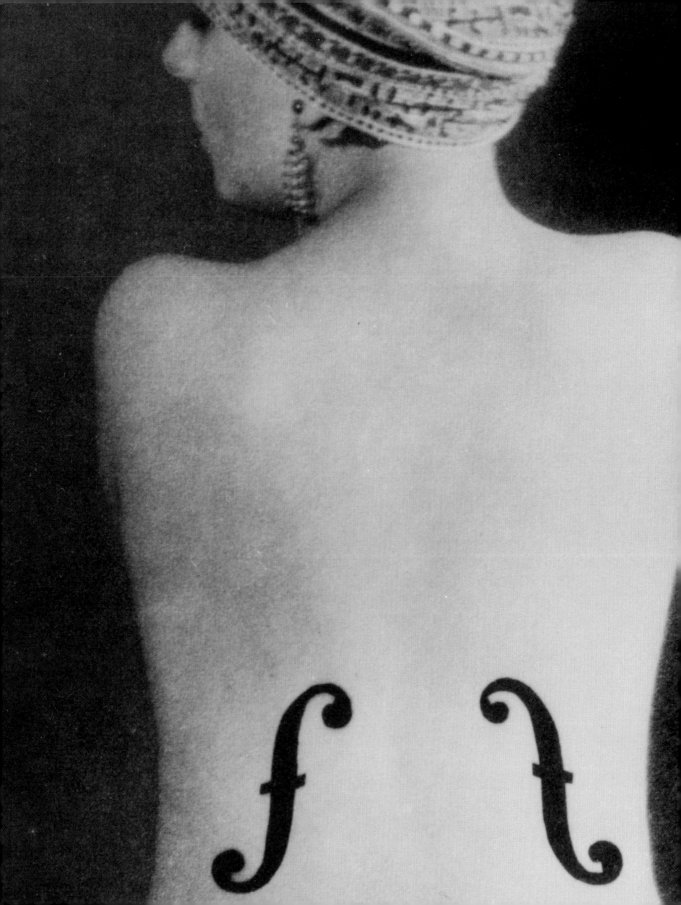

PLATE 37 *Le Violon d'Ingres* (Ingres' Violin), 1924

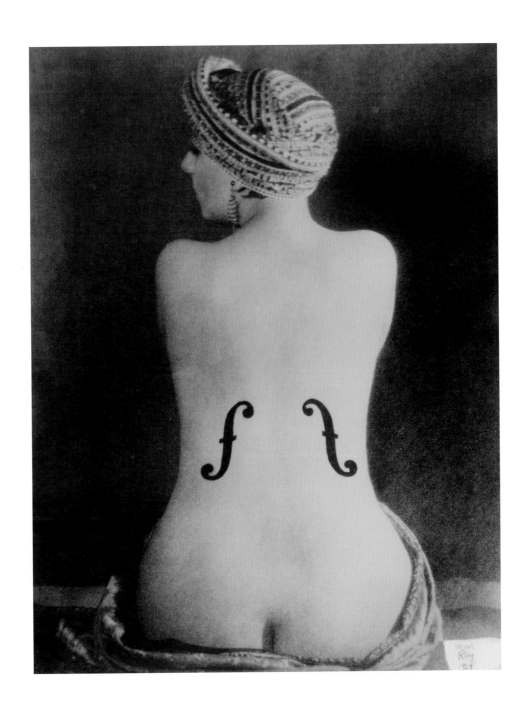

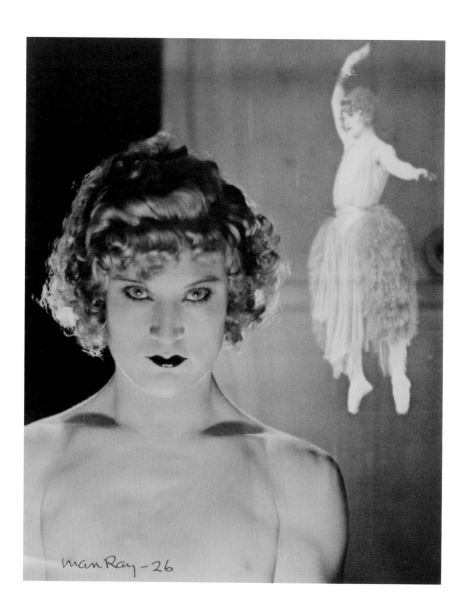

**PLATE 38** *Barbette*, 1926

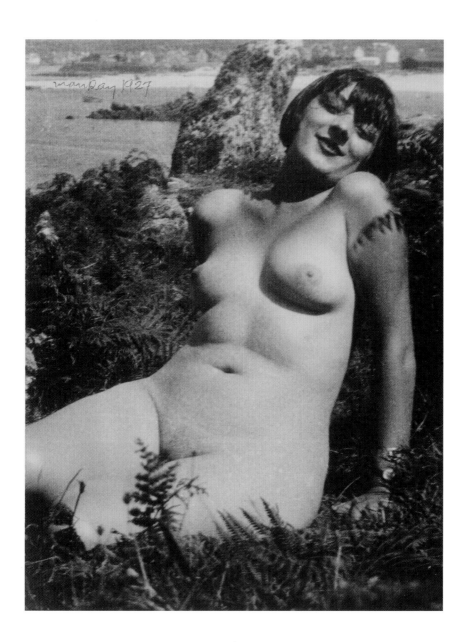

**PLATE 39**  Untitled (Kiki of Montparnasse), 1927

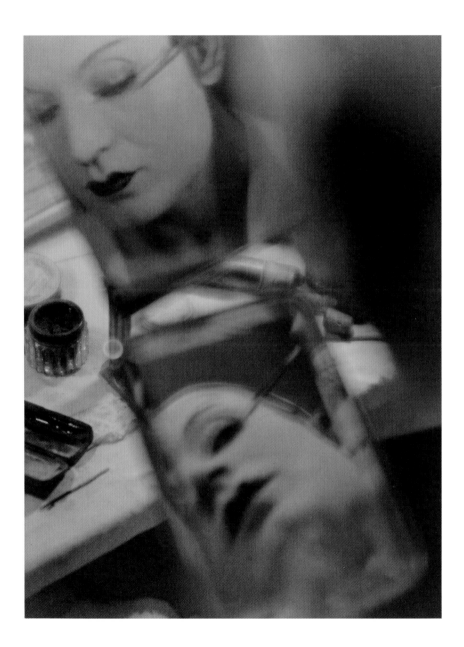

**PLATE 40** *Barbette Making Up*, 1926

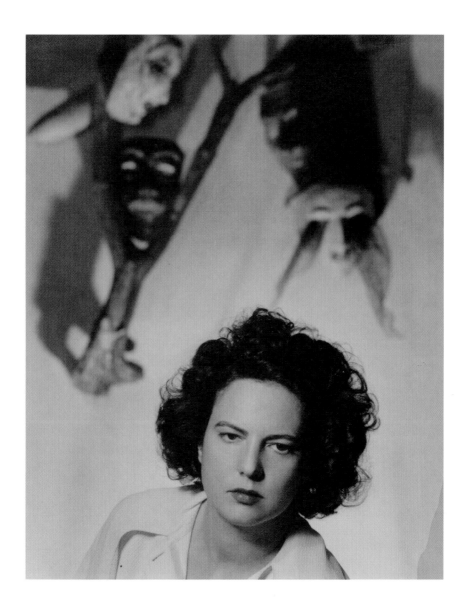

**PLATE 41**  Untitled (Florence Meyer Homolka), 1920s

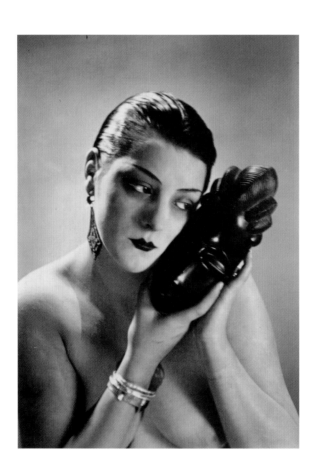

**PLATE 42** *Noire et Blanche* (Black and White), 1926

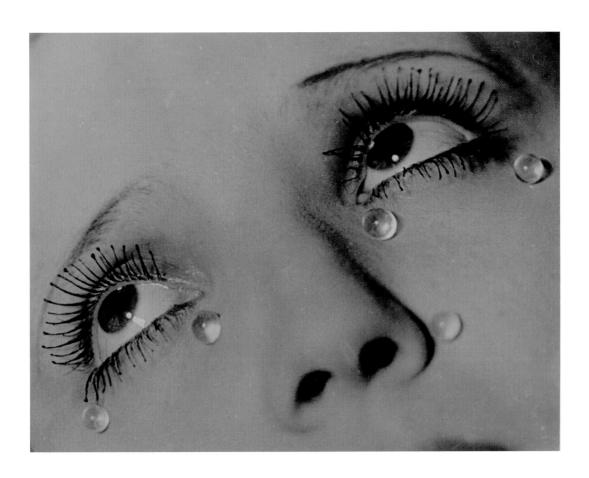

**PLATE 43**  *Larmes* (Tears), 1930–32

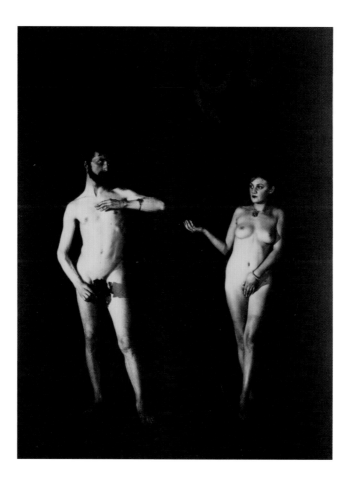

**PLATE 44**  *Ciné-Sketch: Adam and Eve*
(Marcel Duchamp and Brogna Perlmütter), 1924–25

**PLATE 45**  Untitled (Kiki Standing Nude), 1925

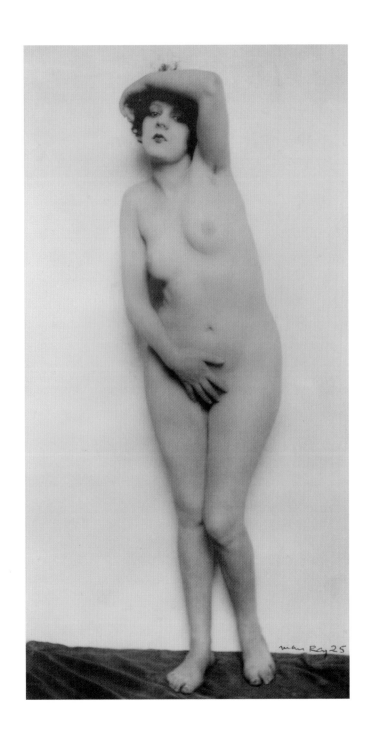

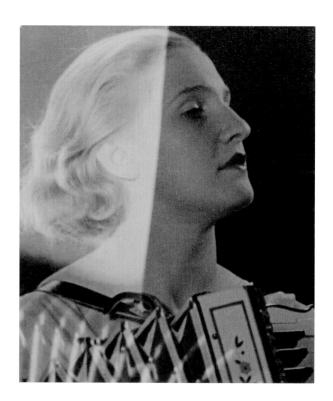

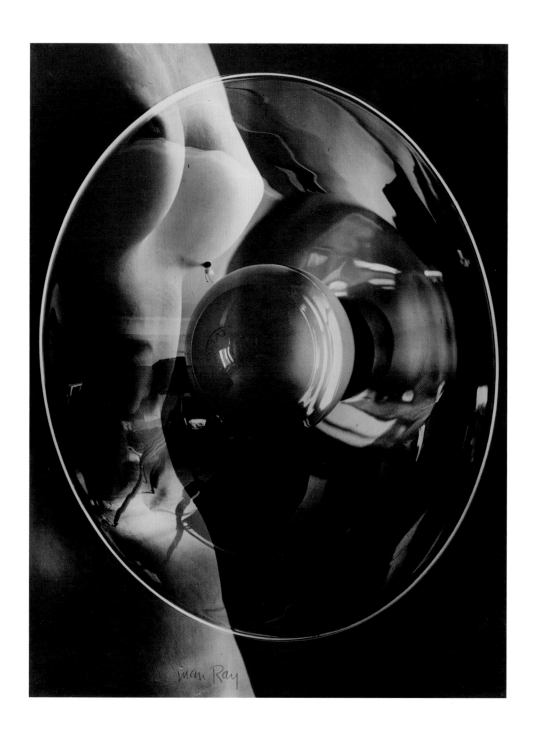

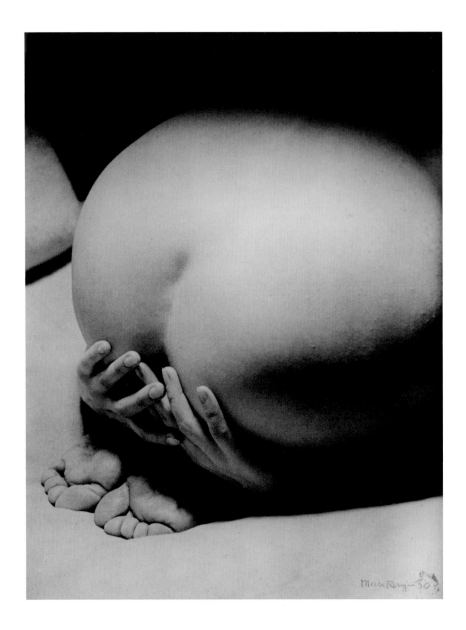

**PLATE 48** *La Prière* (Prayer), negative, 1930; print, 1960

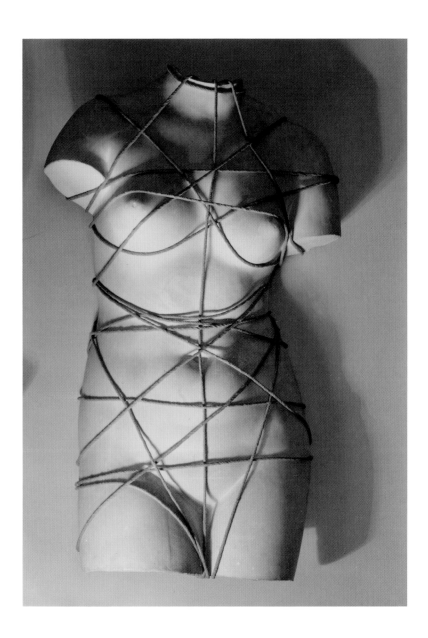

**PLATE 49** *Vénus restaurée* (Restored Venus), 1936

Man Ray was commissioned in 1931 by la Compagnie parisienne de distribution d'électricité (the Paris electric company) to make a series of photographs promoting the domestic uses of electricity. Titled *Électricité*, the portfolio consisted of ten photogravures with a text by Pierre Bost and was produced in an edition of 450. The company distributed the portfolio to top executives and special customers. Man Ray created the photogravures from multiple exposures and Rayographs, processes that celebrated electrical light.

ÉLECTRICITÉ

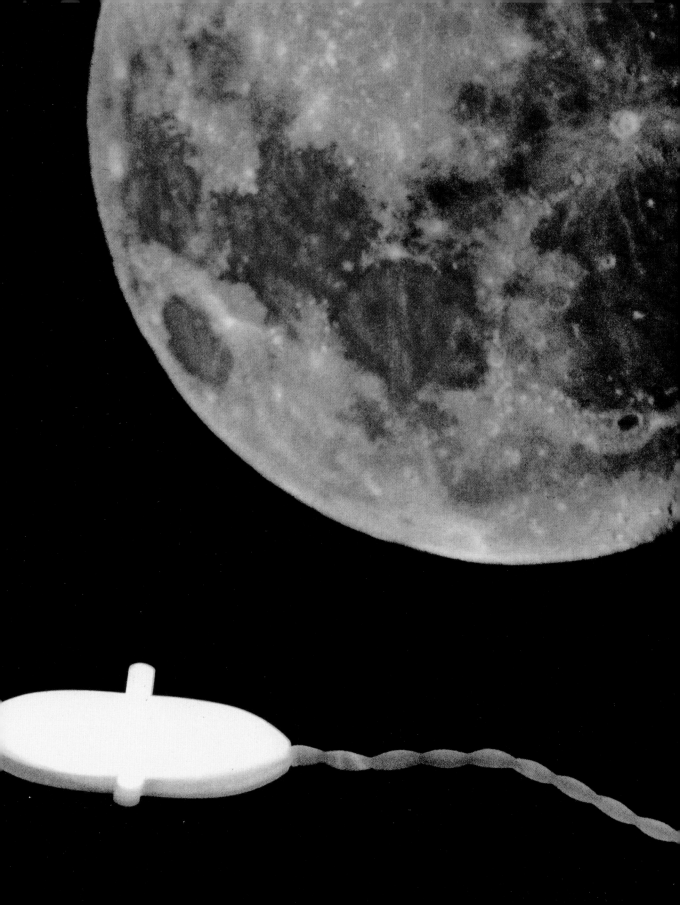

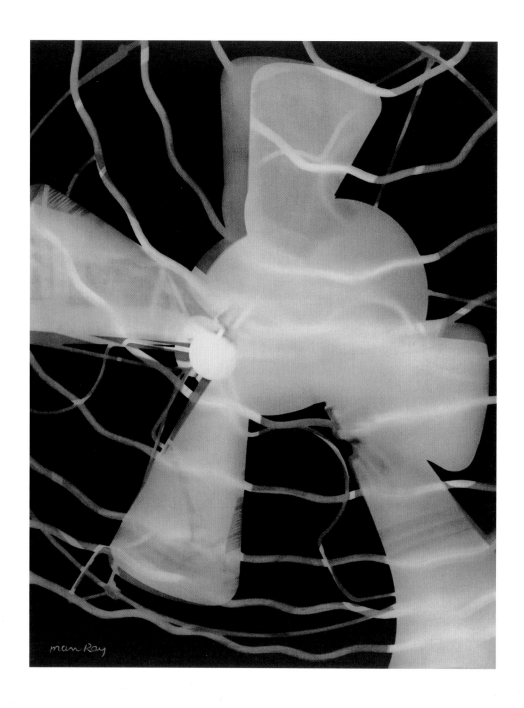

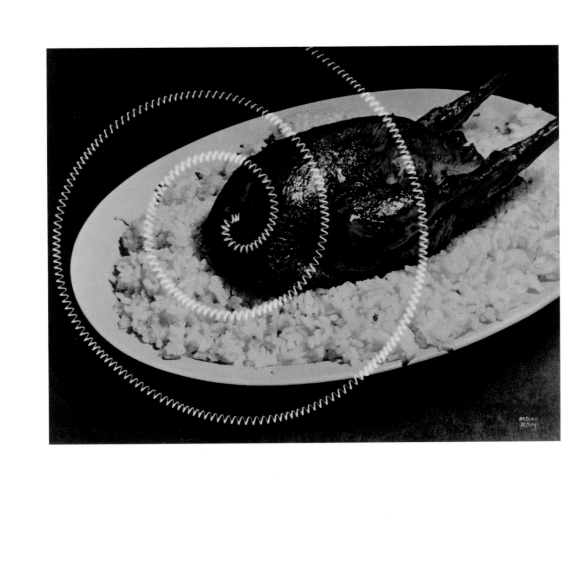

**PLATE 50** *Le Souffle* (Breeze), 1931          **PLATE 51** *Cuisine* (Cooking), 1931

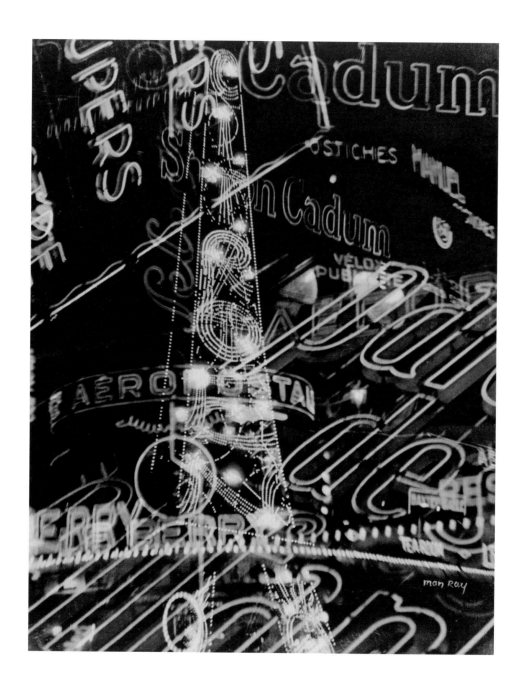

**PLATE 52**  *La Ville* (The City), 1931

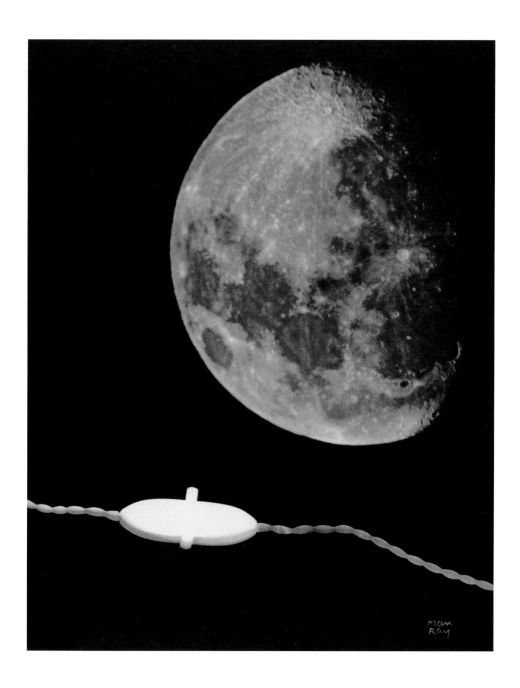

**PLATE 53** *Le Monde* (The World), 1931

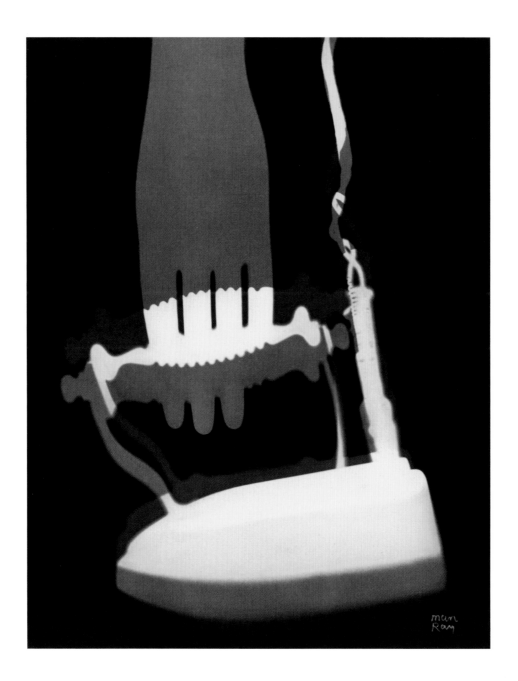

**PLATE 54** *Laundry*, 1931

**PLATE 55** *Électricité*, 1931

Man Ray continually pressed
the boundaries of the
photographic medium. He
experimented with techniques
such as solarization, a
process in which a developing
photograph is briefly
exposed to light, causing
a partial reversal of tones.
The otherworldly effects he
achieved were unpredictable,
adding an element of chance
into otherwise carefully
composed images.

# SOLARIZATION

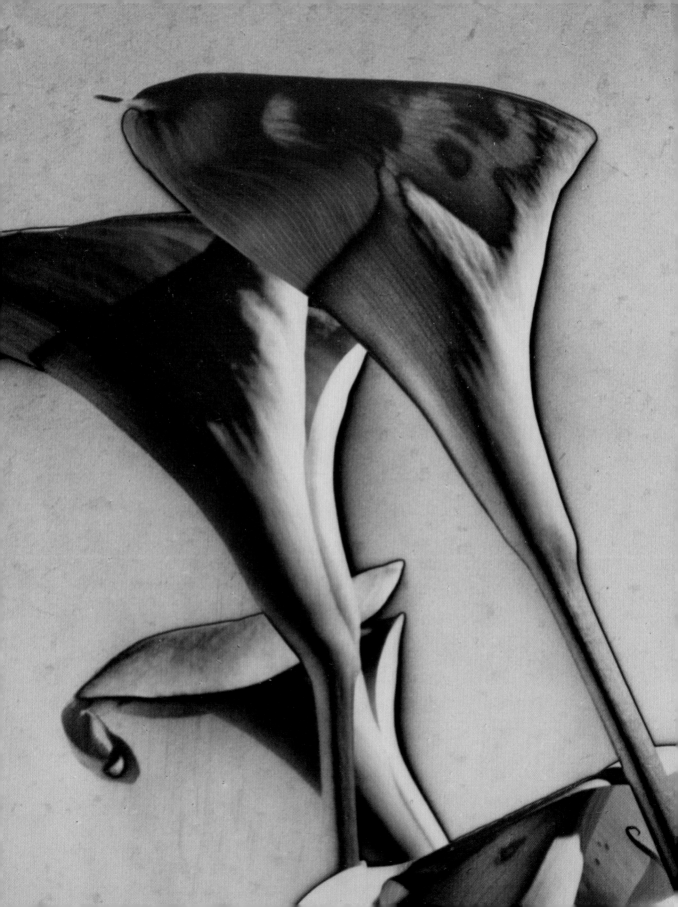

**PLATE 56** *Calla Lilies*, 1930

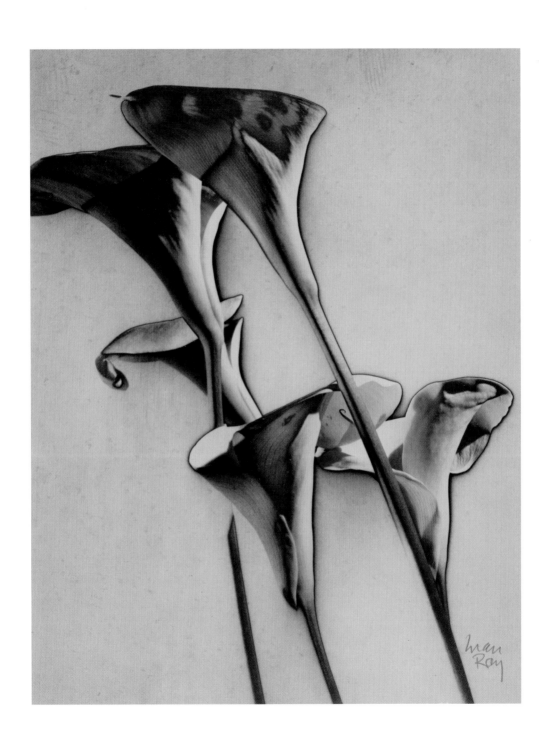

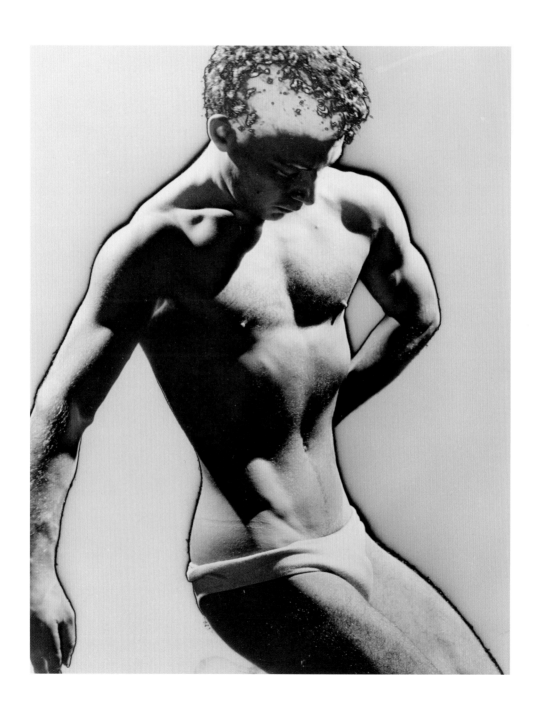

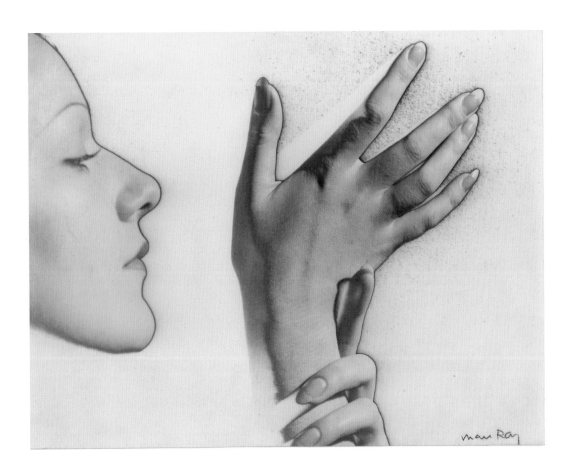

**PLATE 57**  Untitled (Solarized Study of French Actor
Jean-Louis Barrault), 1933

**PLATE 58**  Untitled (Profile and Hands), 1932

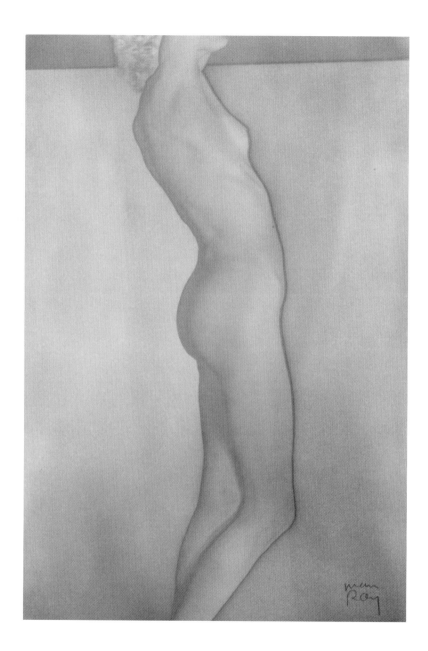

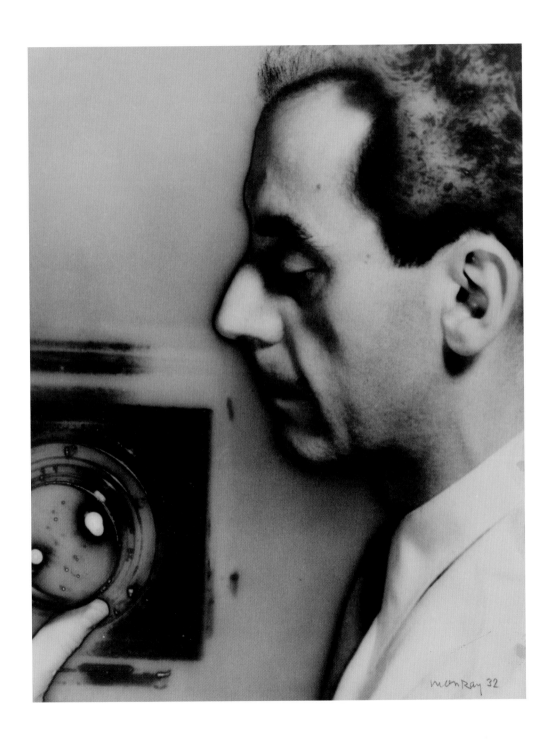

In the 1930s Man Ray experimented with color photography, using the laborious tri-color carbro process. A still life featuring a plaster cast of his head together with *Larmes* (Tears) (plate 43), his masterful image of a woman's eyes shedding glass tears, appeared in the December 1935 issue of the Surrealist publication *Minotaur*. A closely related image, featuring a female model resting her head on the table, became the cover of his first book, an album of photographs published in 1934. Man Ray quickly abandoned color processing until years later, when technologies had greatly improved.

# EXPERIMENTS IN COLOR

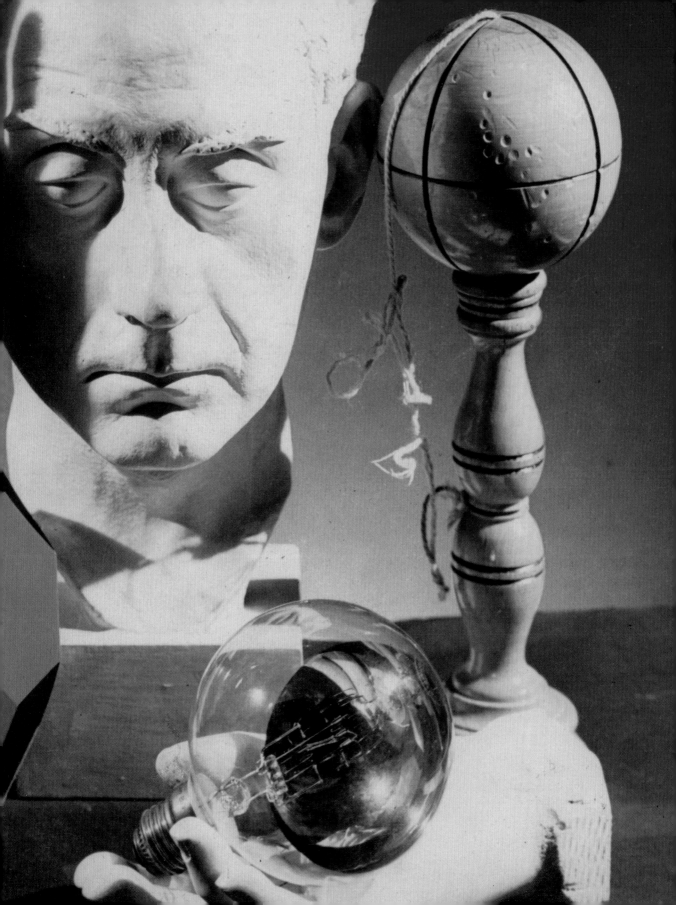

PLATE 61  Untitled (Still Life for *Minotaur*), 1933

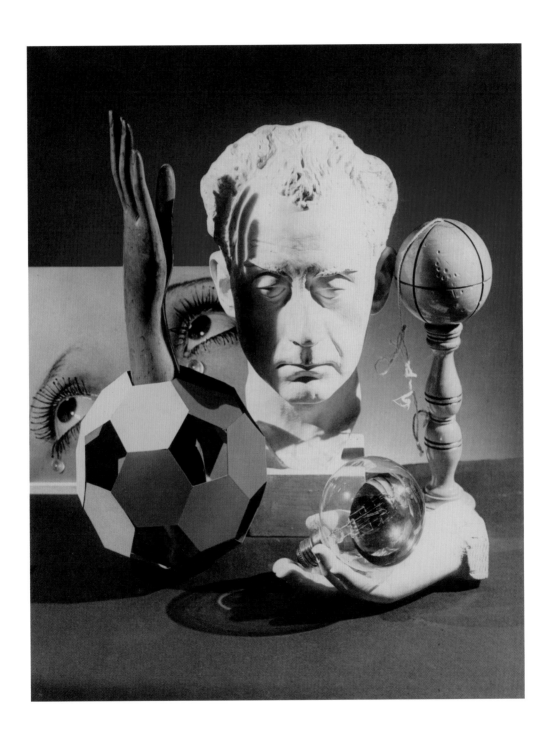

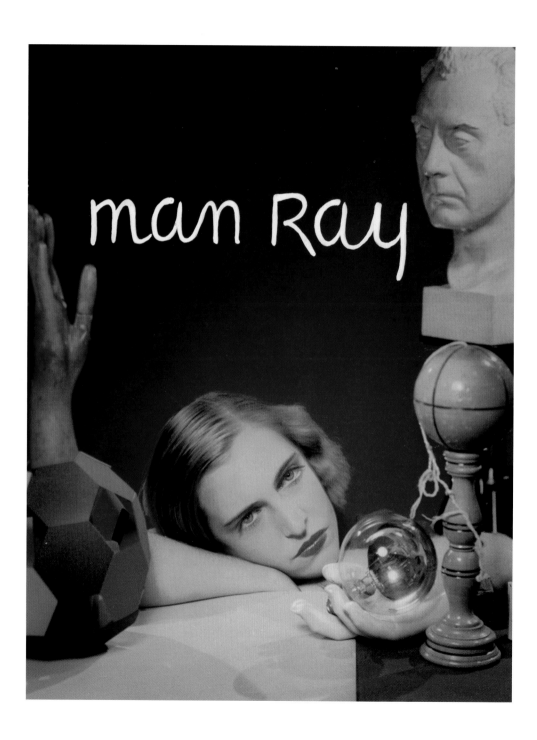

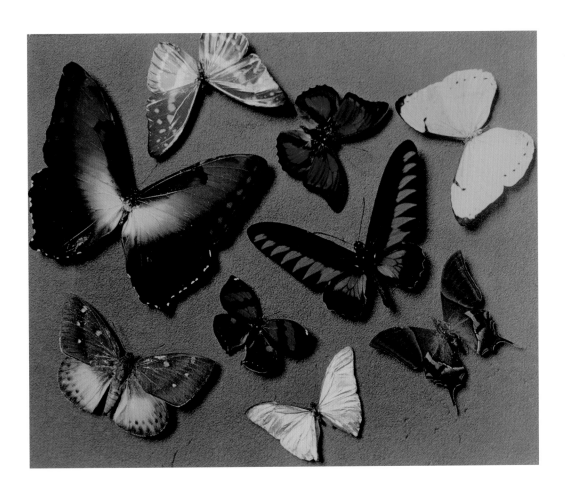

PLATE 62  Untitled (Still Life for Book Cover), 1934          PLATE 63  Untitled (Butterflies), 1935

Found objects, both ordinary and extraordinary, appear throughout Man Ray's work. His Rayographs made use of articles readily at hand, such as his own comb or matches. In addition, he used the camera to explore the properties of utilitarian items; for example, a bottle-drying rack resembled a barbed hoop skirt (see plate 64). Flowers, insects, and other subjects from the natural world also interested Man Ray. In 1934 at the Poincaré Institute, he made a series of photographs of models constructed to give physical form to mathematical formulas (see plates 65, 66). Man Ray would later use the photographs as the basis for paintings of imaginary landscapes.

# OBJECTS

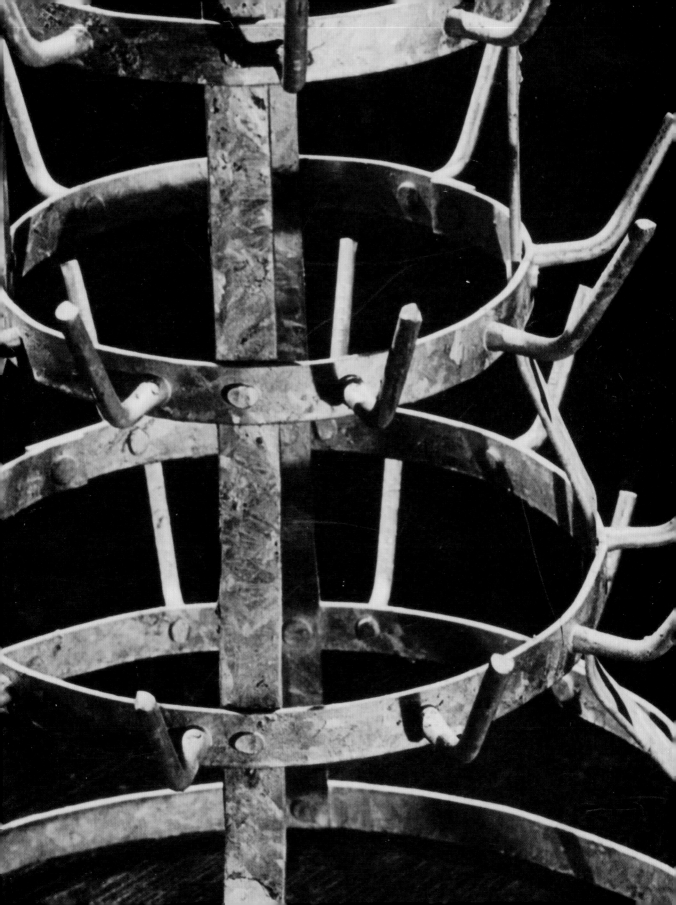

PLATE 64 *Duchamp—Porte bouteille* (Duchamp—Bottle Dryer), 1936

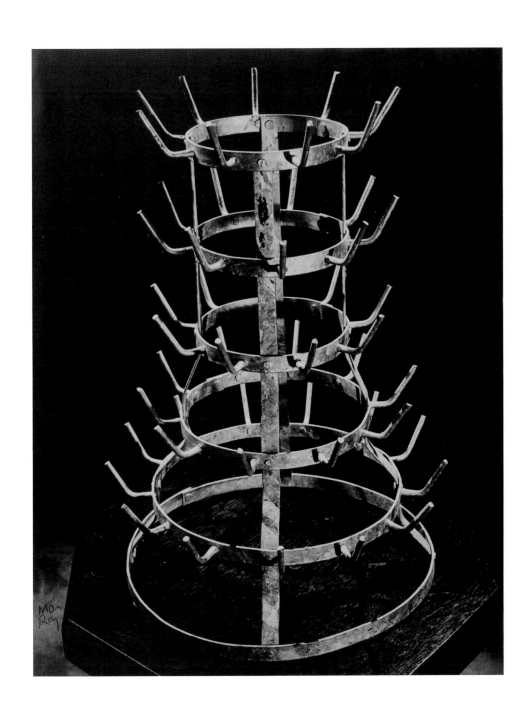

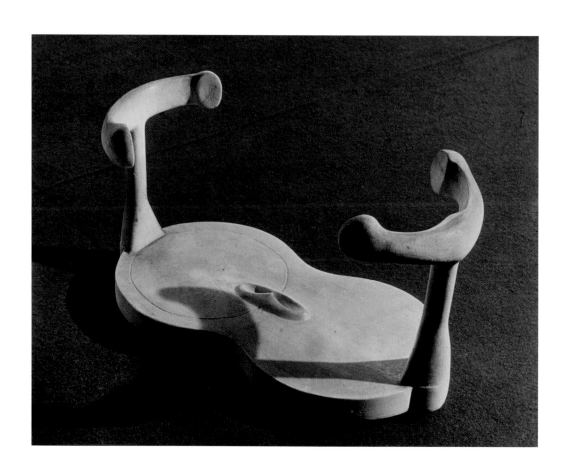

**PLATE 65**  *Mathematical Object, Equation, Poincaré Institute,*
*Paris*, 1934

**PLATE 66**  *Equation, Poincaré Institute, Paris*, 1934

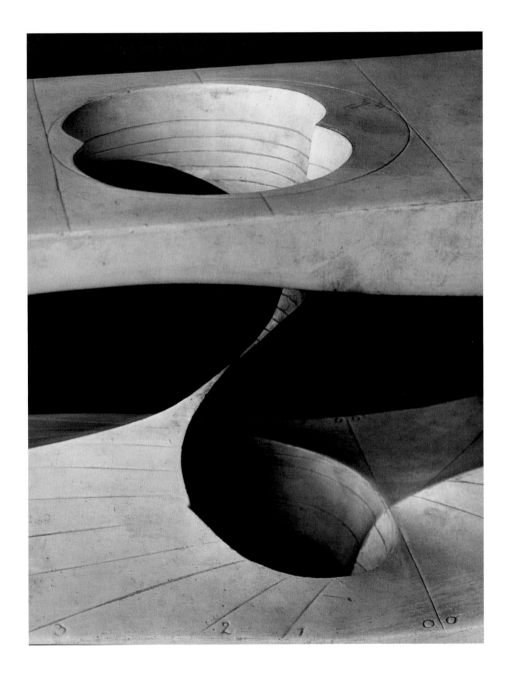

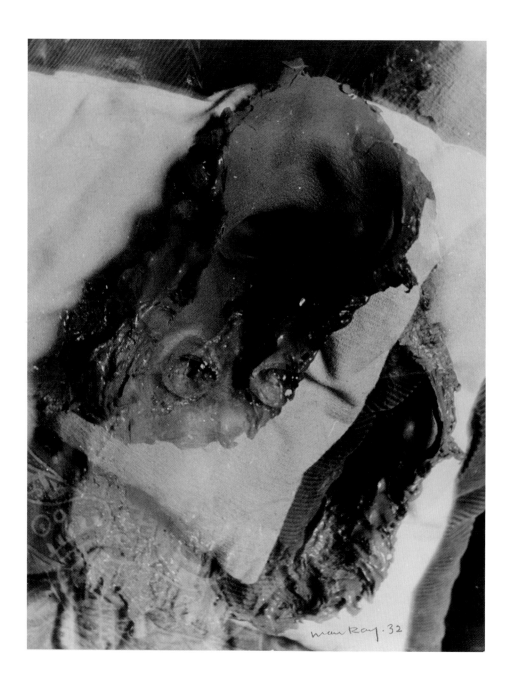

**PLATE 67**  Untitled (Life Mask of Man Ray), 1932

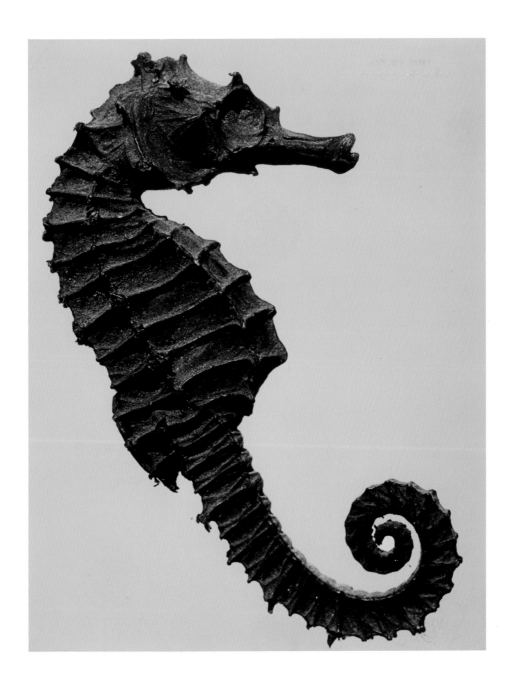

**PLATE 68**  Untitled (Seahorse), 1937

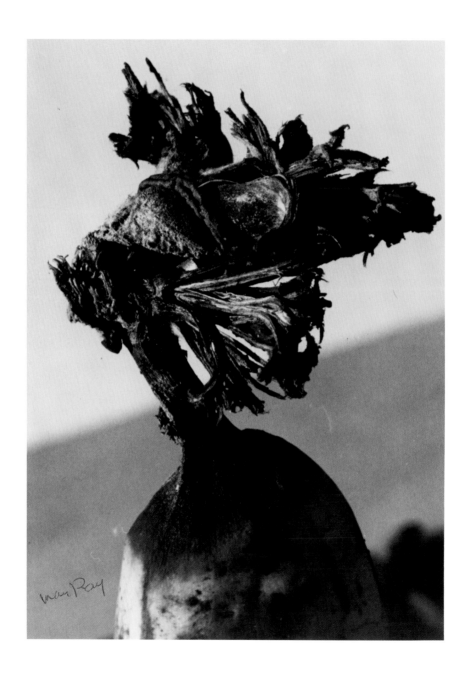

**PLATE 69**  Untitled (Banana Top), 1935          **PLATE 70**  Untitled (Sunflower with Bee), 1925

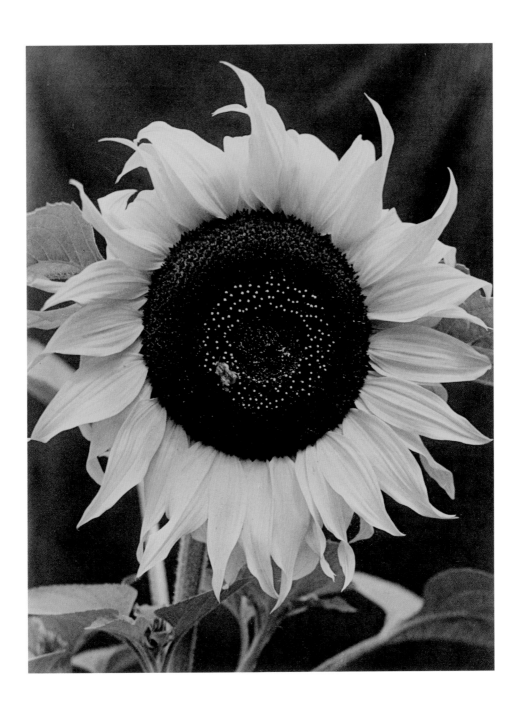

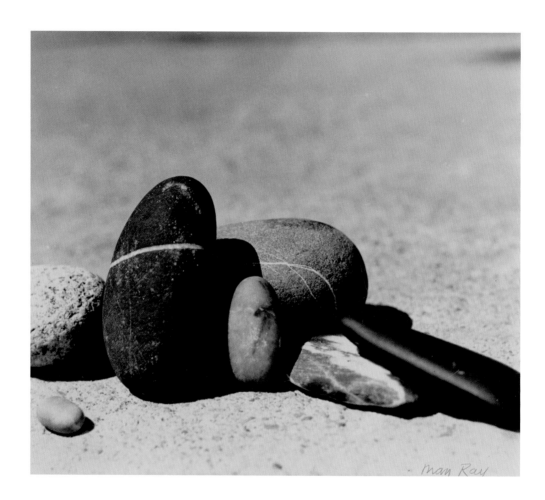

**PLATE 71** Untitled (Study of Pebbles), 1930–34

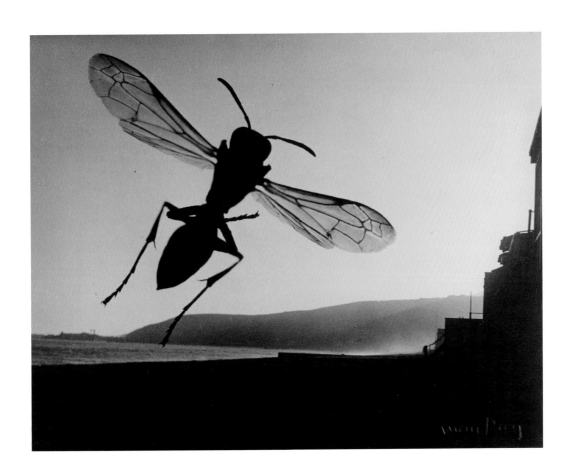

**PLATE 72**  Untitled (Fly), 1935–36

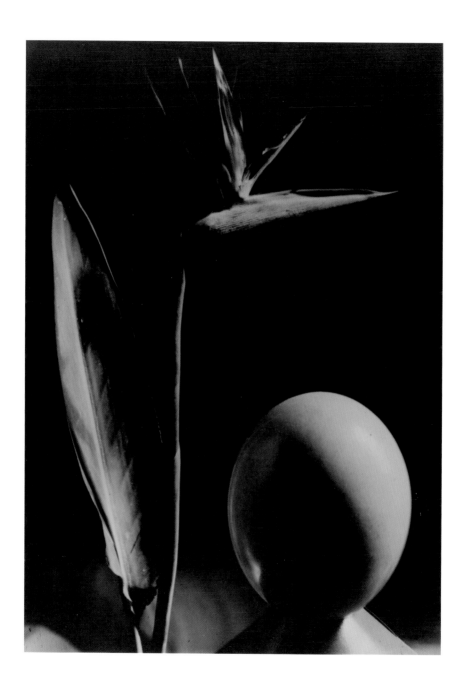

**PLATE 73** Untitled (Composition with Egg and Flower), 1935–36

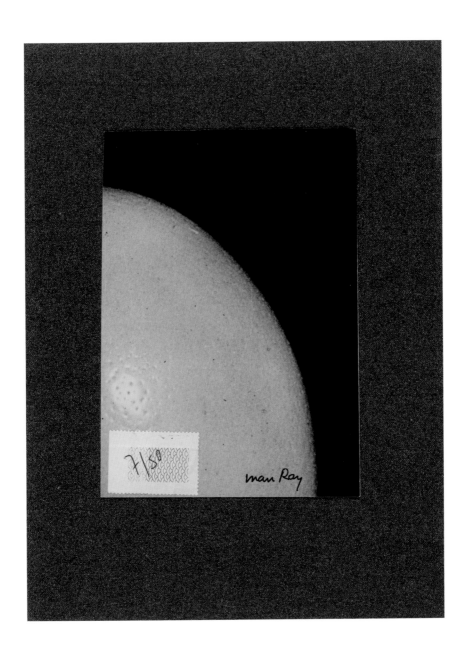

**PLATE 74** Untitled (Ostrich Egg with Stamp), print, 1935; collage, 1960–69

# Plate List

**Note:** All of the photographs listed here are by Man Ray and are in the collection of the J. Paul Getty Museum, Los Angeles. Titles are those assigned by the artist or by contemporary publishers of his work. When a title is given in French, the most commonly used English translation is shown in parentheses. For works designated as "Untitled," a descriptive title follows in parentheses.

**Plate 1**
*"Selbstbildnis" avec les échecs* (Self-Portrait with Chess Set)
1921
Gelatin silver print
18.9 x 14 cm (7 7/16 x 5 1/2 in.)
84.XM.1000.86

**Plate 2**
Untitled (Self-Portrait with Pipe, Paris)
1921
Gelatin silver print
13.2 x 8.3 cm (5 3/16 x 3 1/4 in.)
97.XM.54.1

**Plate 3**
Untitled (Eiffel Tower)
1922
Gelatin silver print
28.3 x 22.9 cm (11 1/8 x 9 in.)
84.XM.1000.45

**Plate 4**
*Rrose Sélavy* (Marcel Duchamp)
1923
Gelatin silver print
22.1 x 17.6 cm (8 11/16 x 6 15/16 in.)
84.XM.1000.80

**Plate 5**
*Belle Haleine* (Beautiful Breath)
1921
Gelatin silver print
22.4 x 17.8 cm (8 13/16 x 7 in.)
85.XM.386.3

**Plate 6**
La Joconde *vue par Duchamp* (The *Mona Lisa* as Seen by Duchamp)
1921–22
Gelatin silver print
16.8 x 10.5 cm (6 5/8 x 4 1/8 in.)
86.XM.626.1

**Plate 7**
Untitled (Marcel Duchamp and Raoul de Roussy Playing Chess)
1925
Gelatin silver print
16.7 x 22.5 cm (6 9/16 x 8 7/8 in.)
84.XM.1000.138

**Plate 8**
Untitled (Pipe)
1933
Gelatin silver
29.8 x 23.2 cm (11 3/4 x 9 1/8 in.)
86.XM.626.20

**Plate 9**
Untitled (Chess Set)
1926
Gelatin silver print
12.1 x 16.5 cm (4 3/4 x 6 1/2 in.)
86.XM.626.15

**Plate 10**
Untitled (Still Life for Nusch Eluard)
1925–30
Gelatin silver print
13.8 x 8.9 cm (5 7/16 x 3 1/2 in.)
84.XM.230.1

**Plate 11**
Untitled Rayograph (Gun with Alphabet Stencils)
1924
Gelatin silver print
29.5 x 23.5 cm (11 5/8 x 9 1/4 in.)
84.XM.1000.171

**Plate 12**
Untitled Rayograph (Kiki and Filmstrips)
1922
Gelatin silver print
23.8 x 17.8 cm (9 3/8 x 7 in.)
84.XM.1000.173

**Plate 13**
Untitled Rayograph
1923
Gelatin silver print mounted to wood veneer over board
Image: 21.5 x 17.2 cm (8 7/16 x 6 3/4 in.);
mount: 26.8 x 20.8 cm (10 9/16 x 8 3/16 in.)
Gift of Marc and Jane Nathanson
2000.14

**Plate 14**
Untitled Rayograph (Net and Shavings)
1924
Gelatin silver print
39.8 x 29.8 cm (15 11/16 x 11 3/4 in.)
84.XM.1000.161

**Plate 15**
Untitled Rayograph (Hand and Flower)
1925
Gelatin silver print
29.4 x 23.5 cm (11 9/16 x 9 1/4 in.)
84.XM.1000.165

**Plate 16**
Untitled Rayograph (Smoke)
1928
Gelatin silver print
24.6 x 19.8 cm (9 11/16 x 7 13/16 in.)
84.XM.1000.159

**Plate 17**
Untitled Rayograph (Snakeskin)
1927
Gelatin silver print
30 x 25.1 cm (11 13/16 x 9 7/8 in.)
84.XM.1000.155

**Plate 18**
Untitled Rayograph (Sequins)
1930
Gelatin silver print
28.4 x 22.7 cm (11 3/16 x 8 15/16 in.)
84.XM.1000.62

**Plate 19**
*Necklace and Bracelet*
1927
Gelatin silver print
22.9 x 17.6 cm (9 x 6 15/16 in.)
84.XM.1000.154

**Plate 20**
Untitled (The Marquise Casati)
1922
Gelatin silver print
11.9 x 8.9 cm (4 11/16 x 3 1/2 in.)
84.XM.1000.136

**Plate 21**
*Philippe Soupault*
1922
Gelatin silver print
12.1 x 8.7 cm (4 3/4 x 3 7/16 in.)
84.XM.1000.82

**Plate 22**
*Sinclair Lewis*
1922
Gelatin silver print
23.2 x 17.1 cm (9 1/8 x 6 3/4 in.)
84.XM.1000.87

**Plate 23**
*Jean Cocteau*
1922
Gelatin silver print
11.9 x 9.8 cm (4 11/16 x 3 7/8 in.)
84.XM.839.3

**Plate 24**
*James Joyce*
1922
Gelatin silver print
25.1 x 20.3 cm (9 7/8 x 8 in.)
84.XM.1000.75

**Plate 25**
Untitled (Gertrude Stein Posing for Sculptor Jo Davidson)
1926
Gelatin silver print
29.2 x 23.5 cm (11 1/2 x 9 1/4 in.)
84.XM.1000.88

**Plate 26**
*Tsuguharu Fujita*
1922
Gelatin silver print
28.1 x 22.9 cm (11 1/16 x 9 in.)
84.XM.1000.65

**Plate 27**
Untitled (Yves Tanguy)
1936
Gelatin silver print
23.2 x 17.8 cm (9 1/8 x 7 in.)
84.XM.1000.79

**Plate 28**
Untitled (Joan Miró)
1936
Gelatin silver print
23 x 17.6 cm (9 1/16 x 6 15/16 in.)
84.XM.1000.146

**Plate 29**
*Nature Morte* (Still Life)
1924
Gelatin silver print
17.8 x 12.7 cm (7 x 5 in.)
84.XM.1000.106

**Plate 30**
Untitled (The Marquise Casati with Horses)
1935
Gelatin silver print
15.4 x 10.3 cm (6 1/16 x 4 1/16 in.)
84.XM.1000.68

**Plate 31**
Untitled Rayograph
1922
From the portfolio *Les Champs délicieux*
(The Delicious Fields)
Gelatin silver print
21.7 x 17.1 cm (8 9/16 x 6 3/4 in.)
84.XM.840.2

**Plate 32**
Untitled Rayograph
1922
From the portfolio *Les Champs délicieux*
(The Delicious Fields)
Gelatin silver print
22.2 x 17 cm (8 3/4 x 6 11/16 in.)
84.XM.840.1

**Plate 33**
Untitled Rayograph
1922
From the portfolio *Les Champs délicieux*
(The Delicious Fields)
Gelatin silver print
22.4 x 17.5 cm (8 13/16 x 6 7/8 in.)
84.XM.840.8

**Plate 34**
Untitled Rayograph
1922
From the portfolio *Les Champs délicieux*
(The Delicious Fields)
Gelatin silver print
21.7 x 17 cm (8 9/16 x 6 11/16 in.)
84.XM.840.9

**Plate 35**
Untitled Rayograph
1922
From the portfolio *Les Champs délicieux*
(The Delicious Fields)
Gelatin silver print
21.9 x 17.1 cm (8 5/8 x 6 3/4 in.)
84.XM.840.11

**Plate 36**
Untitled Rayograph
1922
From the portfolio *Les Champs délicieux*
(The Delicious Fields)
Gelatin silver print
22.2 x 17.1 cm (8 3/4 x 6 3/4 in.)
84.XM.840.12

**Plate 37**
*Le Violon d'Ingres* (Ingres' Violin)
1924
Gelatin silver print
29.6 x 22.7 cm (11 5/8 x 8 15/16 in.)
86.XM.626.10

**Plate 38**
*Barbette*
1926
Gelatin silver print
21.6 x 17.1 cm (8 1/2 x 6 3/4 in.)
84.XM.1000.39

**Plate 39**
Untitled (Kiki of Montparnasse)
1927
Gelatin silver print
17.3 x 12.9 cm (6 13/16 x 5 1/16 in.)
84.XM.1000.50

**Plate 40**
*Barbette Making Up*
1926
Gelatin silver print
21.9 x 16.4 cm (8 5/8 x 6 7/16 in.)
84.XM.839.1

**Plate 41**
Untitled (Florence Meyer Homolka)
1920s
Gelatin silver print
24.9 x 19.8 cm (9 13/16 x 7 13/16 in.)
97.XM.54.4

**Plate 42**
*Noire et Blanche* (Black and White)
1926
Gelatin silver print
11.1 x 7.8 cm (4 3/8 x 3 1/16 in.)
86.XM.626.14

**Plate 43**
*Larmes* (Tears)
1930–32
Gelatin silver print
22.9 x 29.8 cm (9 x 11 3/4 in.)
84.XM.230.2

**Plate 44**
*Ciné-Sketch: Adam and Eve* (Marcel Duchamp
and Brogna Perlmütter)
1924–25
Gelatin silver print
11.6 x 8.7 cm (4 9/16 x 3 7/16 in.)
86.XM.626.12

**Plate 45**
Untitled (Kiki Standing Nude)
1925
Gelatin silver print
28.1 x 14.3 cm (11 1/16 x 5 5/8 in.)
84.XM.1000.46

**Plate 46**
Untitled (Eva with Accordion)
1932
Gelatin silver print
9.7 x 8.4 cm (3 13/16 x 3 5/16 in.)
86.XM.626.19

**Plate 47**
*Intérieur* (Interior)
1932
Gelatin silver print
29.8 x 22.4 cm (11 3/4 x 8 13/16 in.)
84.XM.1000.126

**Plate 48**
*La Prière* (Prayer), negative, 1930;
print, 1960
Gelatin silver print
24 x 18.1 cm (9 7/16 x 7 1/8 in.)
84.XM.1000.52

**Plate 49**
*Vénus restaurée* (Restored Venus)
1936
Gelatin silver print
16.5 x 11.4 cm (6 1/2 x 4 1/2 in.)
86.XM.626.23

**Plate 50**
*Le Souffle* (Breeze)
1931
From the portfolio *Électricité* (Electricity)
Photogravure
26 x 18.6 cm (10 1/4 x 7 5/16 in.)
84.XM.1000.102

**Plate 51**
*Cuisine* (Cooking)
1931
From the portfolio *Électricité* (Electricity)
Photogravure
19.7 x 26 cm (7 3/4 x 10 1/4 in.)
84.XM.1000.5

**Plate 52**
*La Ville* (The City)
1931
From the portfolio *Électricité* (Electricity)
Photogravure
26 x 20.5 cm (10 ¼ x 8 ⅛ in.)
84.XM.1000.99

**Plate 53**
*Le Monde* (The World)
1931
From the portfolio *Électricité* (Electricity)
Photogravure
26 x 20.5 cm (10 ¼ x 8 ⅛ in.)
84.XM.1000.104

**Plate 54**
*Laundry*
1931
From the portfolio *Électricité* (Electricity)
Photogravure
26 x 20.5 cm (10 ¼ x 8 ⅛ in.)
84.XM.1000.103

**Plate 55**
*Électricité*
1931
From the portfolio *Électricité* (Electricity)
Photogravure
26 x 20.5 cm (10 ¼ x 8 ⅛ in.)
84.XM.1000.96

**Plate 56**
*Calla Lilies*
1930
Gelatin silver print, solarized
29.1 x 22.7 cm (11 ⁷⁄₁₆ x 8 ¹⁵⁄₁₆ in.)
84.XM.1000.11

**Plate 57**
Untitled (Solarized Study of French Actor
Jean-Louis Barrault)
1933
Gelatin silver print, solarized
34.3 x 27 cm (13 ½ x 10 ⅝ in.)
84.XM.839.4

**Plate 58**
Untitled (Profile and Hands)
1932
Gelatin silver print, solarized
17.9 x 22.9 cm (7 ⅛ x 9 in.)
84.XM.839.5

**Plate 59**
Untitled (Nusch Eluard)
1935
Gelatin silver print, solarized
22.7 x 15.4 cm (8 ¹⁵⁄₁₆ x 6 ¹⁄₁₆ in.)
84.XM.1000.61

**Plate 60**
Untitled (Self-Portrait with Camera)
1932
Gelatin silver print, solarized
29.2 x 22.9 cm (11 ½ x 9 in.)
84.XM.1000.14

**Plate 61**
Untitled (Still Life for *Minotaur*)
1933
Three-color carbon transfer print
30.6 x 23.8 cm (12 ¹⁄₁₆ x 9 ⅜ in.)
84.XM.1000.6

**Plate 62**
Untitled (Still Life for Book Cover)
1934
Three-color carbon transfer print
30.2 x 23.2 cm (11 ⅞ x 9 ⅛ in.)
84.XM.1000.23

**Plate 63**
Untitled (Butterflies)
1935
Carbro print
23.5 x 28.6 cm (9 ¼ x 11 ¼ in.)
84.XP.446.18

**Plate 64**
*Duchamp—Porte bouteille* (Duchamp—
Bottle Dryer)
1936
Gelatin silver print
30 x 23.2 cm (11 ¹³⁄₁₆ x 9 ⅛ in.)
86.XM.626.2

**Plate 65**
*Mathematical Object, Equation, Poincaré
Institute, Paris*
1934
Gelatin silver print
23.2 x 29.5 cm (9 ⅛ x 11 ⅝ in.)
84.XM.1000.58

**Plate 66**
*Equation, Poincaré Institute, Paris*
1934
Gelatin silver print
30 x 23.3 cm (11 ¹³⁄₁₆ x 9 ³⁄₁₆ in.)
84.XM.1000.59

**Plate 67**
Untitled (Life Mask of Man Ray)
1932
Gelatin silver print
29.7 x 23 cm (11 ¹¹⁄₁₆ x 9 ¹⁄₁₆ in.)
84.XM.1000.119

**Plate 68**
Untitled (Seahorse)
1937
Gelatin silver
30 x 23.2 cm (11 ¹³⁄₁₆ x 9 ⅛ in.)
84.XP.447.22

**Plate 69**
Untitled (Banana Top)
1935
Gelatin silver print
24 x 17.3 cm (9 ⁷⁄₁₆ x 6 ¹³⁄₁₆ in.)
84.XM.1000.49

**Plate 70**
Untitled (Sunflower with Bee)
1925
Gelatin silver print
29.8 x 23 cm (11 ¾ x 9 ¹⁄₁₆ in.)
84.XM.1000.51

**Plate 71**
Untitled (Study of Pebbles)
1930–34
Gelatin silver print
19.5 x 22.9 cm (7 ¹¹⁄₁₆ x 9 in.)
85.XM.389

**Plate 72**
Untitled (Fly)
1935–36
Gelatin silver print
19.4 x 24.8 cm (7 ⅝ x 9 ¾ in.)
84.XM.1000.131

**Plate 73**
Untitled (Composition with Egg and Flower)
1935–36
Gelatin silver print
29.4 x 20.8 cm (11 ⁹⁄₁₆ x 8 ³⁄₁₆ in.)
86.XM.626.13

**Plate 74**
Untitled (Ostrich Egg with Stamp),
print, 1935; collage, 1960–69
Stamp and gelatin silver print mounted
on sandpaper
Image: 14.9 x 11 cm (5 ⅞ x 4 ⁵⁄₁₆ in.);
mount: 24.2 x 17.7 cm (9 ½ x 6 ¹⁵⁄₁₆ in.)
84.XM.1000.121

# Selected Bibliography

**Baldwin, Neil**. *Man Ray: American Artist*. New York, 1988.

**Foresta, Merry**, ed. *Perpetual Motif: The Art of Man Ray*. New York, 1988.

**Klein, Mason**. *Alias Man Ray: The Art of Reinvention*. New York, 2009.

**Krauss, Rosalind**, and Jane Livingston, with an essay by Dawn Ades. *L'Amour Fou: Photography and Surrealism*. New York, 1985.

**Lottman, Herbert R.** *Man Ray's Montparnasse*. New York, 2001.

**Man Ray**, *Self-Portrait*, with an afterword by Juliet Man Ray and a foreword by Merry Foresta. Boston, 1998.

**Ware, Katherine**. *In Focus: Man Ray*. Los Angeles, 1998.

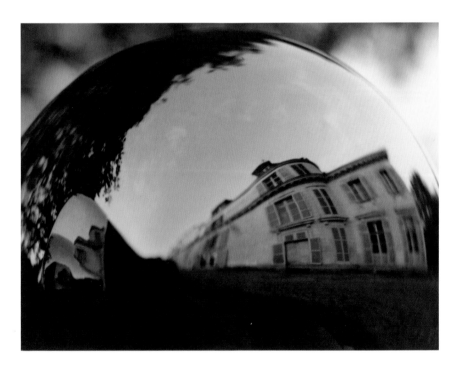

FIGURE 10. Man Ray, Untitled (Distorted House), 1928. Gelatin silver print, 17.6 x 23.2 cm (6 ¹⁵⁄₁₆ x 9 ⅛ in.). Los Angeles, J. Paul Getty Museum, 84.XM.1000.122